More
LOGOS & LETTERHEADS

ROCKPORT
PUBLISHERS

Rockport Publishers, Inc
Gloucester, Massachusetts
Distributed by North Light Books
Cincinnati, Ohio

First published in the United States of America by:
Rockport Publishers, Inc.
33 Commercial Street
Gloucester, Massachusetts 01930-5089
Telephone: (978) 282-9590
Facsimile: (978) 283-2742

Distributed to the book trade and art trade in the United States by:
North Light Books, an imprint of
F & W Publications
1507 Dana Avenue
Cincinnati, Ohio 45207
Telephone: (800) 289-0963

Other Distribution by:
Rockport Publishers, Inc.
Gloucester, Massachusetts 01930-5089

ISBN 1-56496-439-6

10 9 8 7 6 5 4 3 2 1

Production: Sara Day Graphic Design
Cover Images (clockwise from top left): pp. 68, 12, 73, 10, 62, 20, 64, 56

Printed in Hong Kong by Midas Printing Limited.

INTRODUCTION

In today's busy world of world communications, it is easy to deal with a business in a remote place and never actually physically see a person. This is why it is imperative to have a strong logo and letterhead design. The logo must represent the character, personality, aims, and goals of a company.

It takes a designer's genius and ingenuity to create a personable and clear identity. This is much to ask from a simple graphic symbol, yet many of the designs included in this volume have accomplished just that. With logos and letterheads for every type of business, this a comprehensive collection of the most innovative and creative work being done by today's top designers. This volume, in addition to our first edition of *Design Library: Logos and Letterheads,* will prove to be a wonderful resource for clients and designers alike.

CLIENT The Goddard Manton Partnership
DESIGN FIRM John Nash & Friends
DESIGNER John Nash
ART DIRECTOR John Nash
PAPER/PRINTING Four Colors

The Goddard Manton Partnership
ARCHITECTS

Anthony Goddard
ARCHITECT

The Goddard Manton Partnership
67 George Row London SE16 4UH Tel. 01-237 2016
Facsimile 01-237 7850

Don Manton
ARCHITECT

The Goddard Manton Partnership
67 George Row London SE16 4UH Tel. 01-237 2016
Facsimile 01-237 7850

67 GEORGE ROW LONDON SE16 4UH TELEPHONE 01-237 2016 FACSIMILE 01-237 7850
VAT NO. 243 4572 79

CLIENT Margo Chase Design
DESIGN FIRM Margo Chase Design
ART DIRECTOR Margo Chase
DESIGNER Margo Chase
PAPER/PRINTING Three colors on Mountie
Matte White

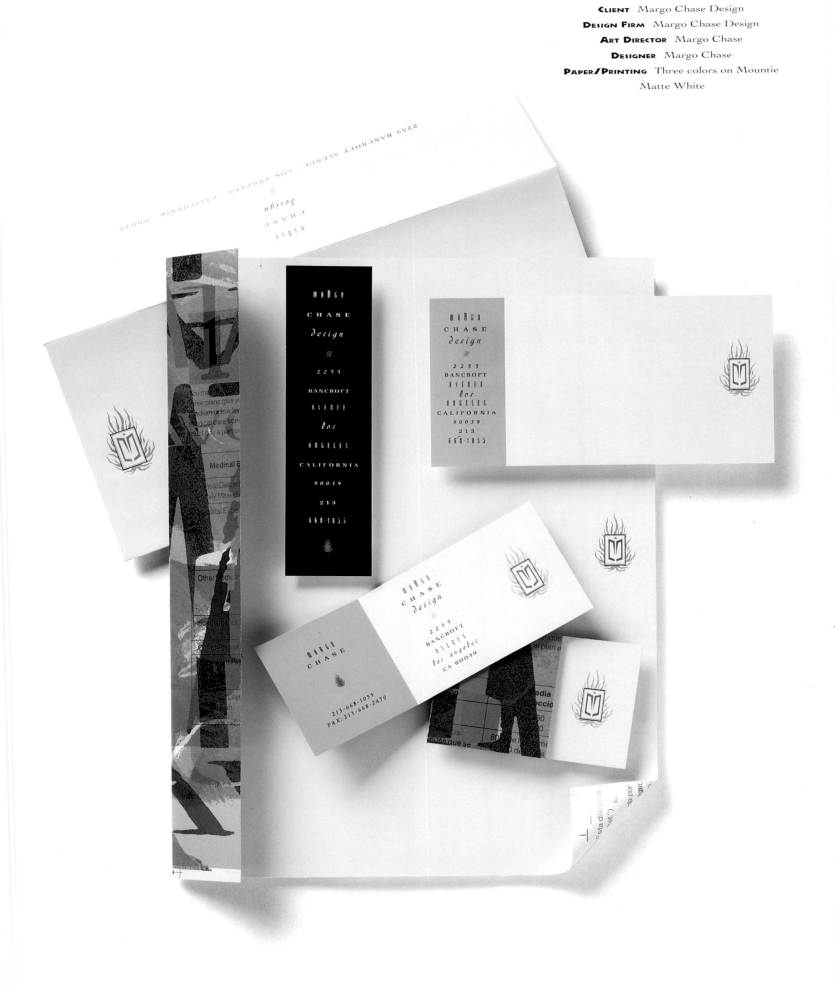

CLIENT Arthur Jack Snyder
DESIGN FIRM Richardson or Richardson
DESIGNER Diane Gilleland
ART DIRECTOR Forrest Richardson
PAPER/PRINTING Stationery: Two colors
on 24-lb. Protocol 100.
Business Card. Two colors on cover stock.

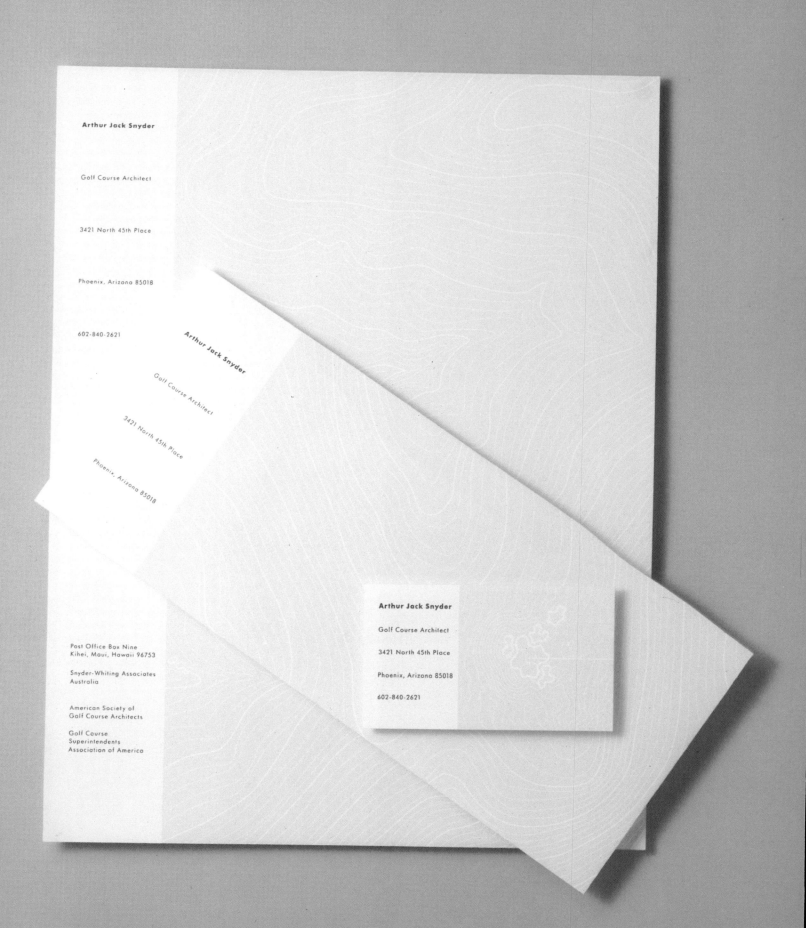

CLIENT Wall Street Advisors
DESIGN FIRM Design Center
ART DIRECTOR John Reger
DESIGNER Todd Spichke
PAPER/PRINTING Four colors

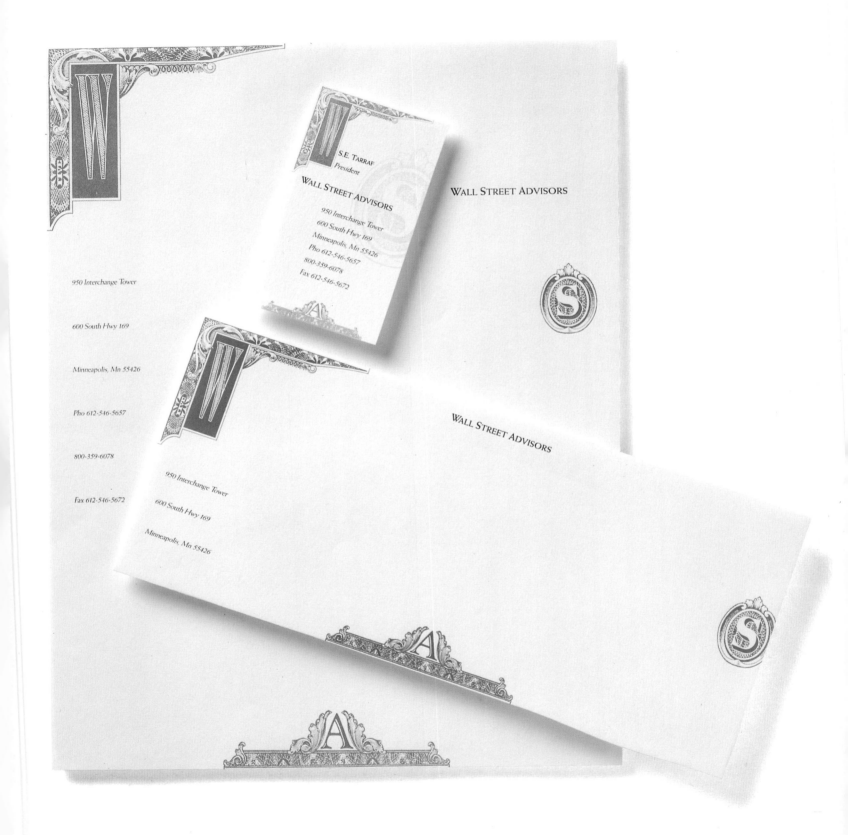

Client Bob Orr/Organizational Team Building
Design Firm The Bradford Lawton Design Group
Designer Bradford Lawton
Art Director Bradford Lawton, Scott Creame
Paper/Printing Two colors on Protocol Bright
White Wove.

ORGANIZATIONAL
TEAM BUILDING

ORGANIZATIONAL
TEAM BUILDING

117 WEST CRAIG PLACE
SAN ANTONIO, TEXAS 78212
(512) 734-7323

117 WEST CRAIG PLACE
SAN ANTONIO, TEXAS 78212
(512) 734-7323

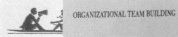

ORGANIZATIONAL TEAM BUILDING

CLIENT Integrus
DESIGN FIRM Hornall Anderson Design Works
ART DIRECTOR John Hornall
DESIGNERS John Hornall, Paula Cox, Brian O'Neill
PAPER/PRINTING Two colors on Neenah Environment

INTĚGRUS
ARCHITECTURE

INTĚGRUS
ARCHITECTURE

WEST 244 MAIN AVENUE
SPOKANE, WA 99201
P.O. BOX 1482 (99210)

FAX 509.838.2194
509.838.8681

915 SEATTLE TOWER
1218 THIRD AVENUE
SEATTLE, WA 98101-3018

The WMFL & ECI traditions continue.

INTĚGRUS
ARCHITECTURE

The WMFL & ECI traditions continue.

INTĚGRUS
ARCHITECTURE

JOHN PLIMLEY, P.E.
STRUCTURAL ENGINEER, PRINCIPAL

WEST 244 MAIN AVENUE
SPOKANE, WA 99201
P.O. BOX 1482 (99210)

FAX 509.838.2194
509.838.8681

The WMFL & ECI traditions continue.

Larry D. Hurlbert
William A. James
Gary D. Joralemon
Bruce F. Mauser
George H. Nachtsheim
Arthur A. Nordling
John Plimley
Gordon E. Ruehl
Thomas M. Shine
Bruce M. Walker
Gerald A. Winkler
Kirklund S. Wise

The WMFL & ECI traditions continue.

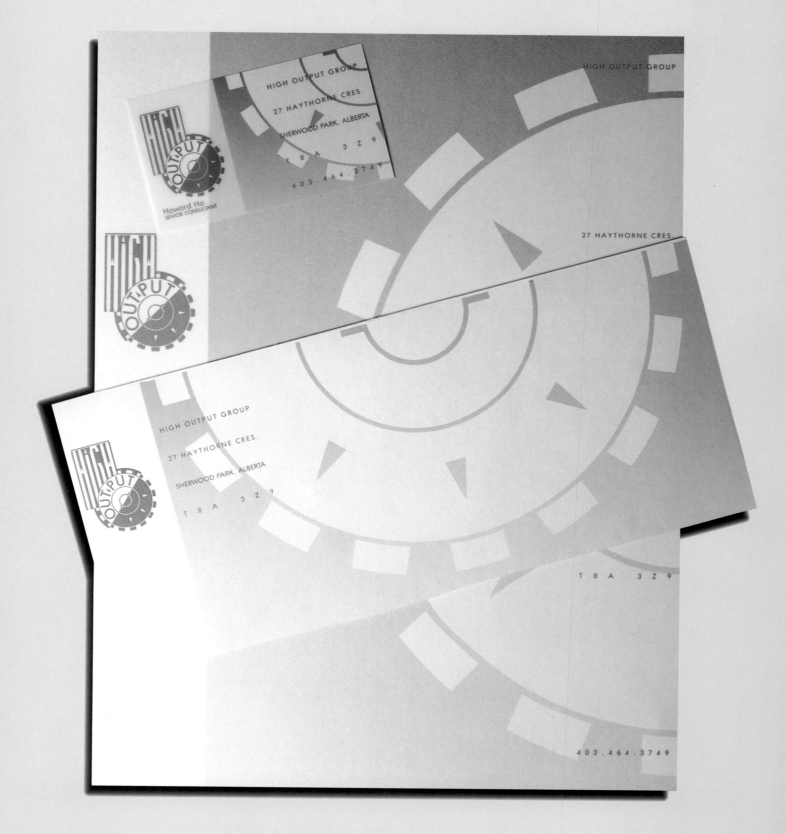

Design Firm Duck Soup Graphics
Art Director William Doucette
Designer/Illustrator Sharon Phillips
Client High Output Group
Paper/Printing UV Ultra Opaque White, printed both sides,
two match colors

The hand-drawn letterhead and business card are printed both
sides on UV Ultra to achieve a highly unique image for this
start-up company.

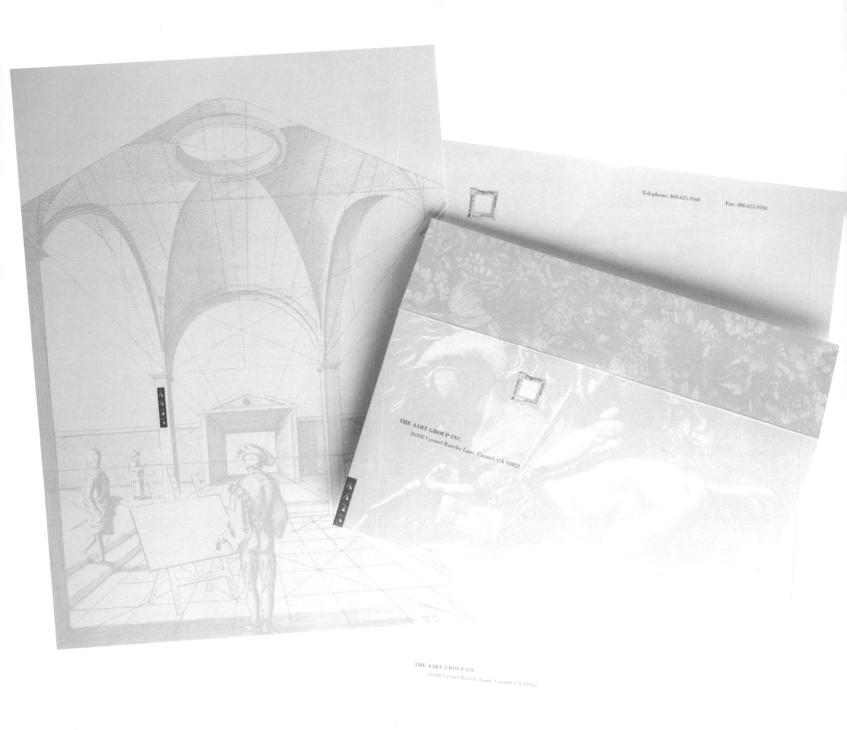

DESIGN FIRM Sackett Design Associates
ART DIRECTOR/DESIGNER Mark Sackett
ILLUSTRATOR Chris Yaryan
CLIENT The AART Group
PAPER/PRINTING Simpson Starwhite Vicksburg 80 lb. text,
offset lithography, black and one match color

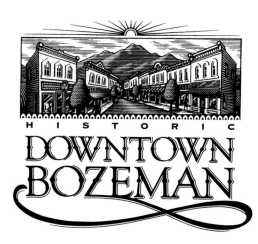

DESIGN FIRM Palmquist & Palmquist Design
ART DIRECTORS/DESIGNERS Kurt and Denise Palmquist
ILLUSTRATORS James Lindquist, Denise Palmquist
CLIENT Downtown Bozeman Association
..
This logo could not focus on one specific building or street because of politics. The illustration was done on scratchboard and the type was a combination of computer- and hand-rendering.

DESIGN FIRM Palmquist & Palmquist Design
ART DIRECTORS/DESIGNERS Kurt and Denise Palmquist
ILLUSTRATOR Kurt Palmquist
CLIENT Coalition for Montanans Concerned with Disabilities
TOOL Aldus FreeHand
..
The logo design focused on the objectives the organization was trying to accomplish: To help disabled persons while educating politicians and professionals about the concerns and goals of the disabled.

DESIGN FIRM Mires Design Inc.
ART DIRECTOR/DESIGNER José Serrano
ILLUSTRATOR Tracy Sabin
CLIENT Harcourt Brace & Co.
..
This logo is for a children's fantasy book series.

DESIGN FIRM Mires Design Inc.
ART DIRECTOR Mike Brower
DESIGNER Mike Brower
CLIENT Bod-E
..
The client is a personal health trainer.

DESIGN FIRM Misha Design Studio
ALL DESIGN Michael Lenn
CLIENT Combined Jewish Philanthropies General Assembly '95
..
The '95 Convention for CJP being held in Boston must demonstrate beauty and excitement. This logo shows the significant landmarks in Boston and invites a participant to the assembly.

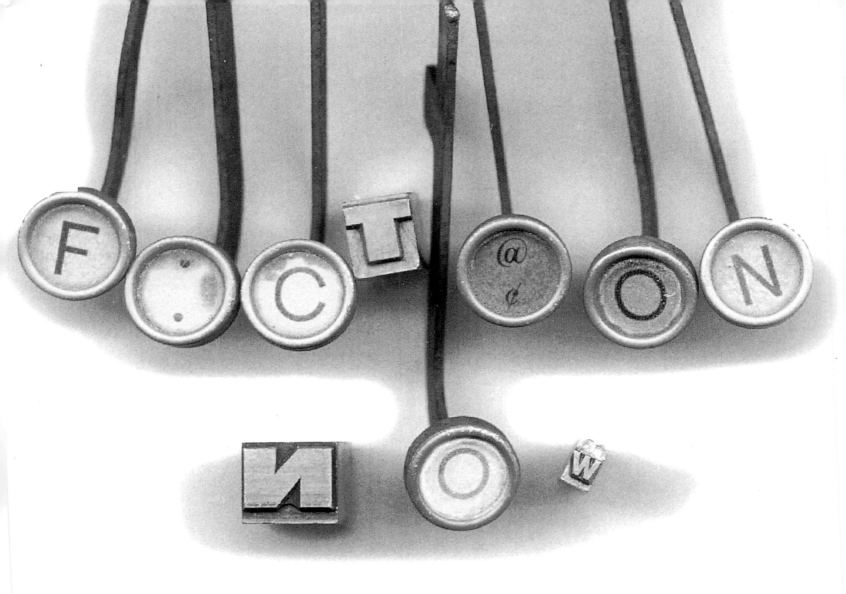

DESIGN Mary Evelyn McGough and Mike Hand for
Mike Salisbury Communications, Inc.
PROJECT *Fiction Now* logo and masthead
CLIENT Francis Ford Coppola/American Zoetrope
TOOLS Adobe Photoshop on Macintosh
FONT Actual old typewriter keys, Franklin Gothic

Fiction Now is a new writers' journal—a forum for new
writers of short fiction. Old type keys were scanned and
manipulated to read as a masthead.

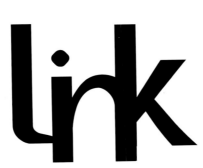

DESIGN Paula Menchen for PJ Graphics
PROJECT Link
TOOLS Adobe Illustrator on Macintosh
FONT Borzoi Reader

This is an unrealized logo design that was manipulated
and altered in Illustrator. The designer used Borzoi
Reader and rescaled and redrew parts of the font.

CLIENT Peninsula Fountain & Grille
DESIGN FIRM Tharp Did It ° Los
Gatos/San Francisco
ART DIRECTOR Rick Tharp
DESIGNER Jana Heer, Jean Mogannam,
Rick Tharp
ILLUSTRATOR Jana Heer
PAPER/PRINTING Two colors on Simpson
EverGreen Recycled

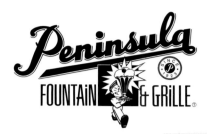

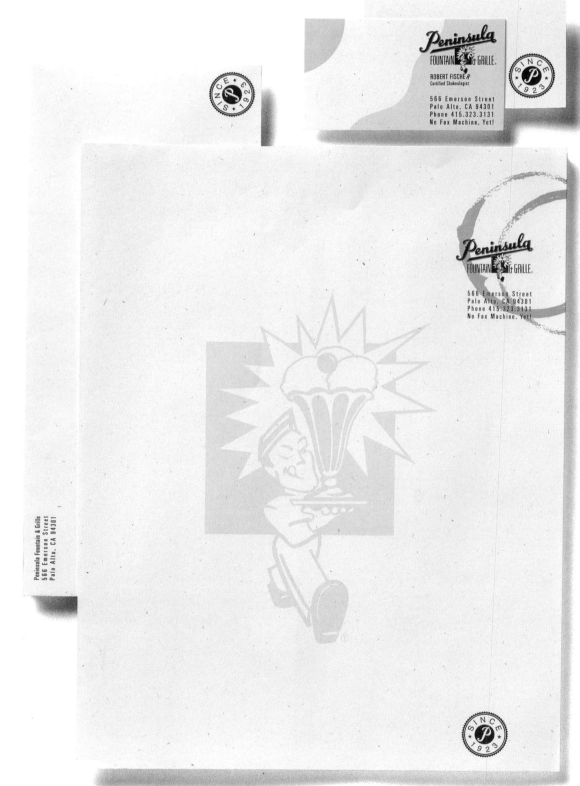

CHARLES R. DRUMMOND

17095 Crescent Drive

Los Gatos, CA 95030

408.354.3387

Strategic Communications

CHARLES R. DRUMMOND
17095 Crescent Drive
Los Gatos, CA 95050
408.354.3387

Strategic Communications

CLIENT Drummond Strategic Communications
DESIGN FIRM Tharp Did It ° Los Gatos/San Francisco
ART DIRECTORS Rick Tharp, Charles Drummond
DESIGNERS Rick Tharp, Thom Marchionna
PAPER/PRINTING Two colors and foil embossing on Simpson Protocol

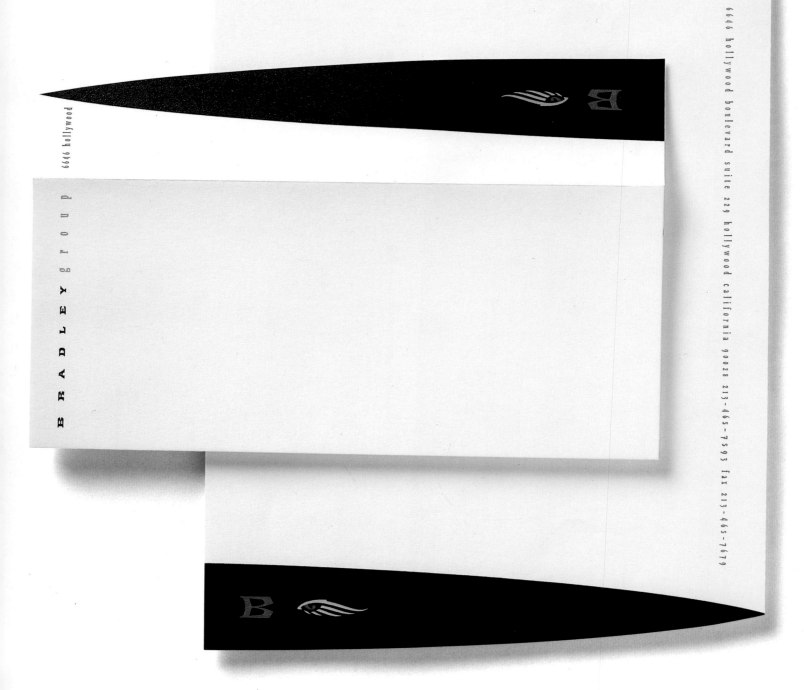

CLIENT Bradley Group
DESIGN FIRM Margo Chase Design
ART DIRECTOR Margo Chase
DESIGNER Margo Chase
PAPER/PRINTING Three colors on Mohawk Suiperfine

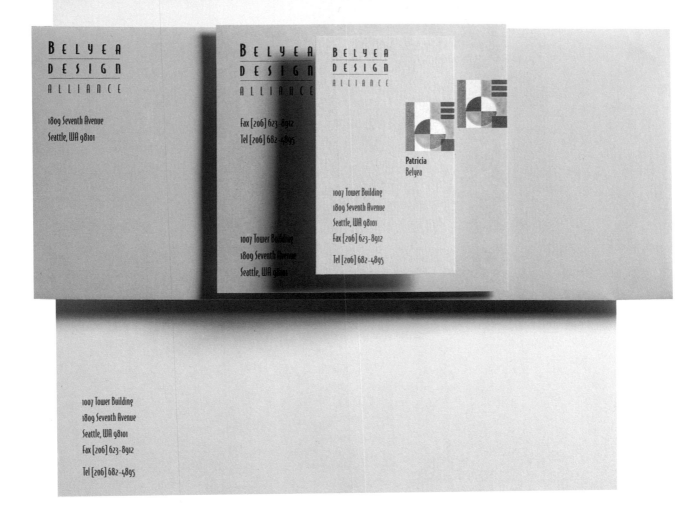

DESIGN FIRM Belyea Design Alliance
ART DIRECTOR Patricia Belyea
DESIGNERS Samantha Hunt, Adrianna Jumping Eagle
ILLUSTRATORS Jani Drewfs, Brian O'Neill
PAPER/PRINTING Simpson Protocol, Ruby Press, 4-color
TOOLS Adobe Photoshop, Aldus FreeHand, Fractal Design Painter

The mark was rendered in FreeHand, colored in Painter and filtered through Photoshop. The set is 4-color printed; a custom match yellow replaces process yellow.

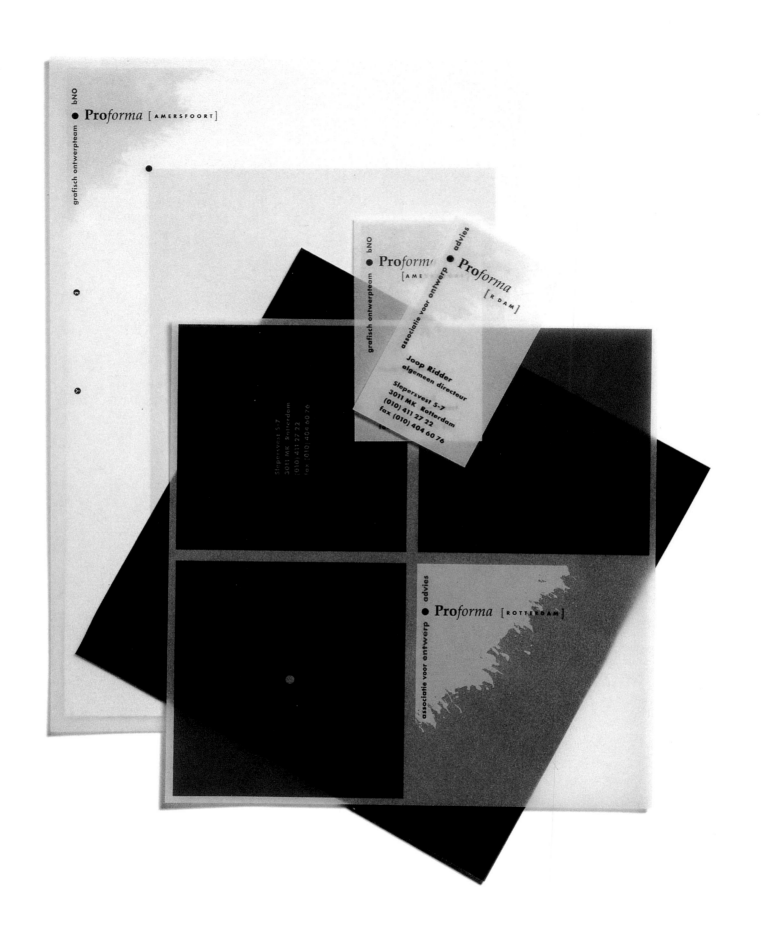

DESIGN FIRM Proforma Rotterdam

ART DIRECTOR Aadvan Dommelen

DESIGNER Gert Jan Rooijakkers

CLIENT Proforma

PAPER/PRINTING Calque

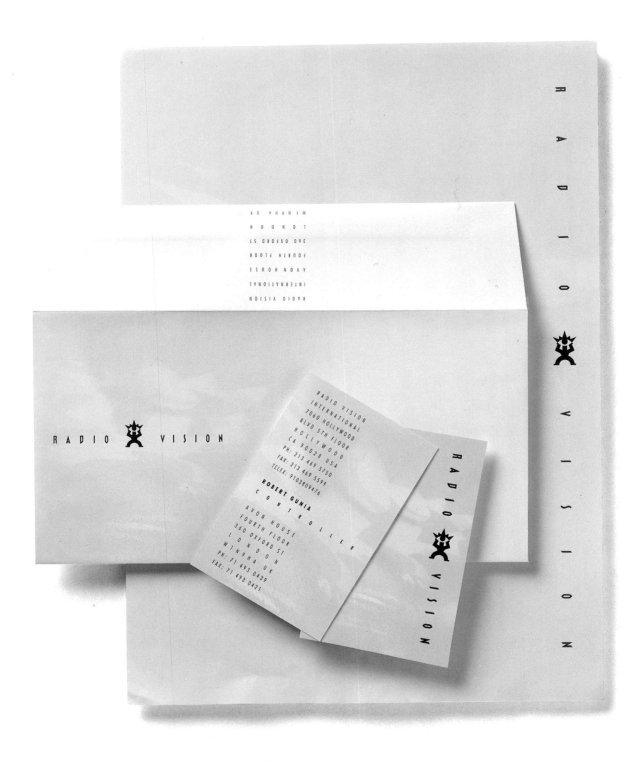

CLIENT Radio Vision International
DESIGN FIRM Margo Chase Design
ART DIRECTOR Margo Chase
DESIGNER Margo Chase
PAPER/PRINTING Three colors on Mountie Matte White

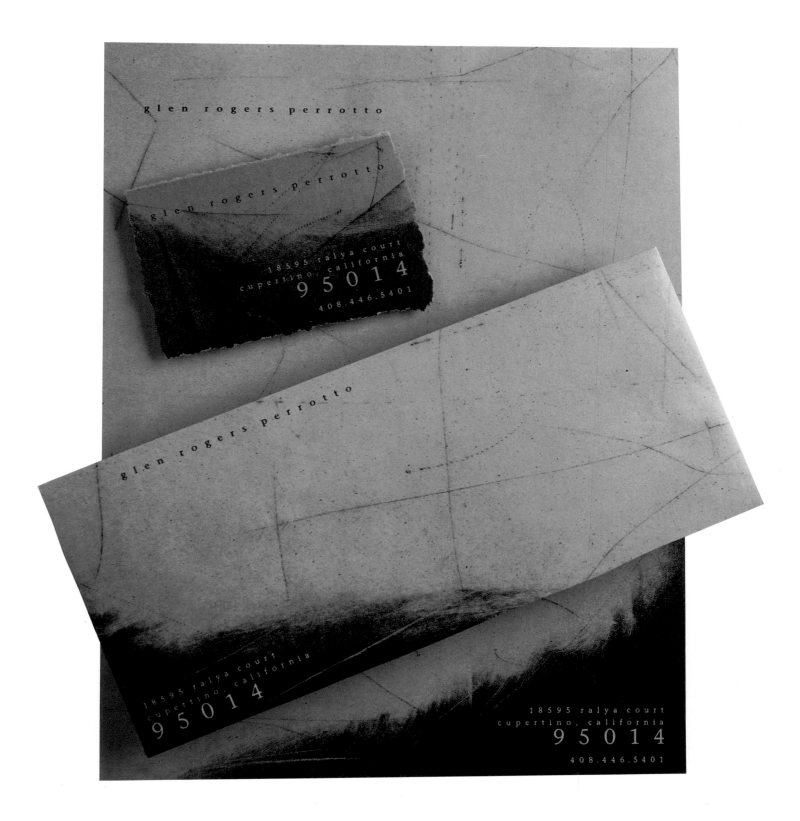

DESIGN FIRM Melissa Passehl Design
ART DIRECTOR/DESIGNER Melissa Passehl
ARTIST Glen Rogers Perrotto
CLIENT Glen Rogers Perrotto

The artist created background art that was reproduced as
line art. The business cards are hand-torn to reinforce the
handmade element.

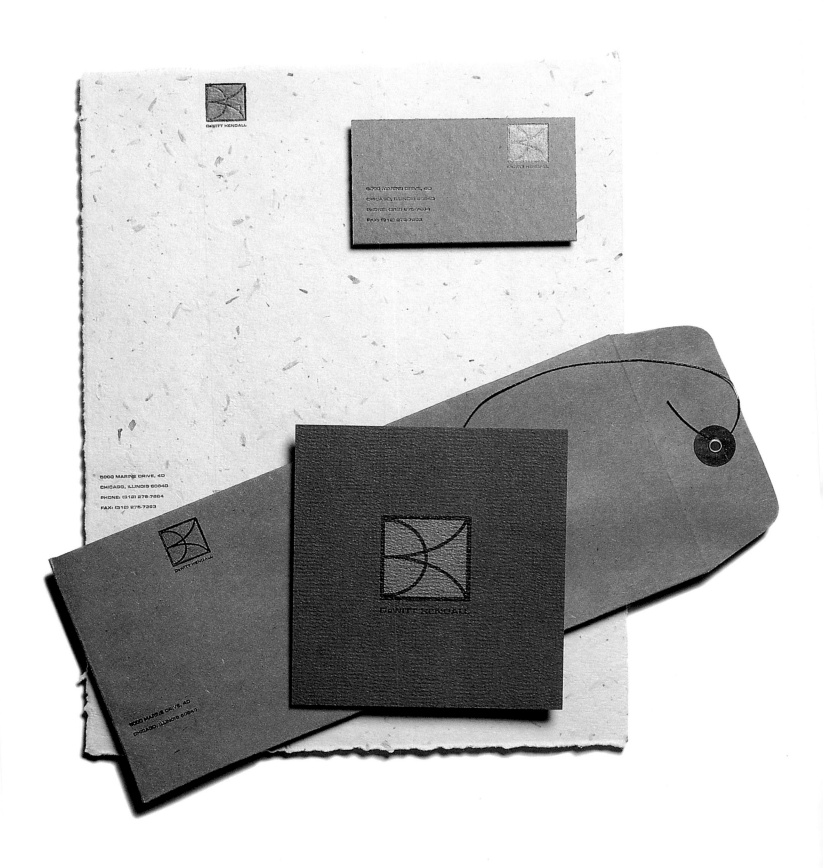

DESIGN FIRM Dewitt Kendall – Chicago
ART DIRECTOR Dewitt Kendall
DESIGNER Dewitt Kendall
ILLUSTRATOR Dewitt Kendall
CLIENT Dewitt Kendall Chicago
PAPER/PRINTING Kraft 3-ply industrial chipboard, handmade rice husk
paper (stationery) Simpson Gainsborough, 2 hits of copper (business card)

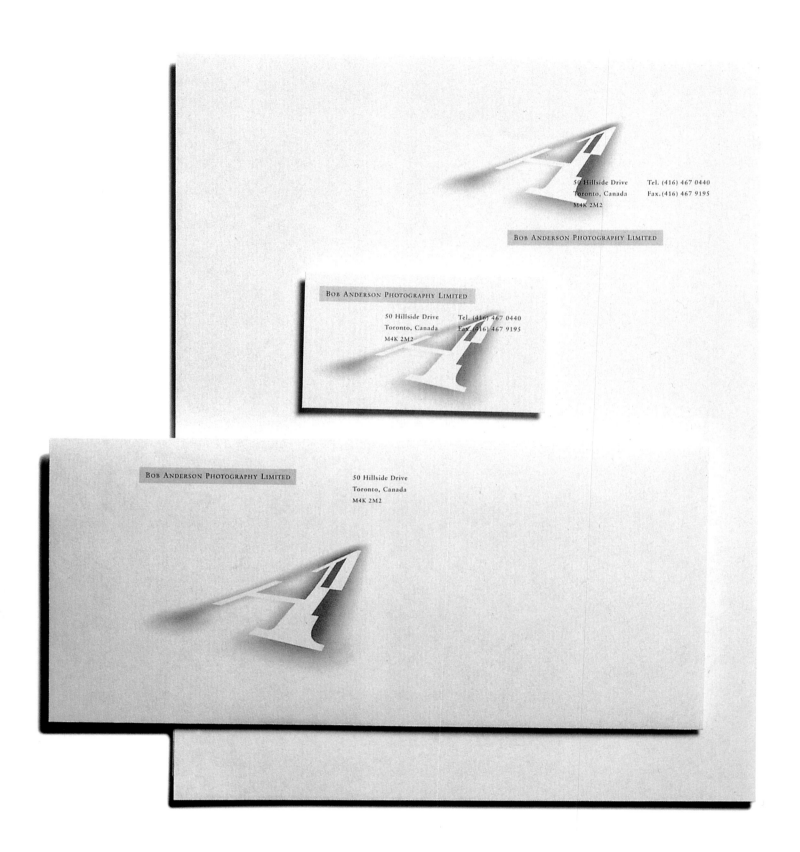

50 Hillside Drive Tel. (416) 467 0440
Toronto, Canada Fax.(416) 467 9195
M4K 2M2

BOB ANDERSON PHOTOGRAPHY LIMITED

BOB ANDERSON PHOTOGRAPHY LIMITED

50 Hillside Drive Tel. (416) 467 0440
Toronto, Canada Fax.(416) 467 9195
M4K 2M2

BOB ANDERSON PHOTOGRAPHY LIMITED

50 Hillside Drive
Toronto, Canada
M4K 2M2

DESIGN FIRM Eskind Waddell
ART DIRECTOR Malcolm Waddell
DESIGNER Nicola Lyon
CLIENT Bob Anderson Photography Ltd.
PAPER/PRINTING Strathmore Script

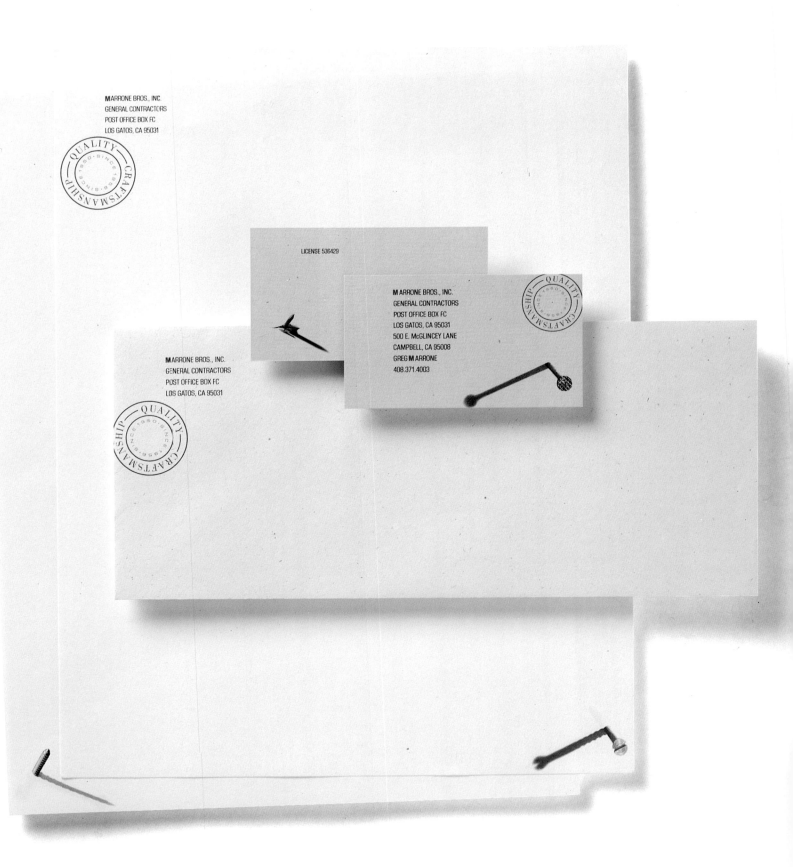

CLIENT Marrone Brothers Construction

DESIGN FIRM Tharp Did It ° Los Gatos/San Francisco

ART DIRECTOR Rick Tharp

DESIGNER Rick Tharp

PAPER/PRINTING Two colors on Simpson Protocol

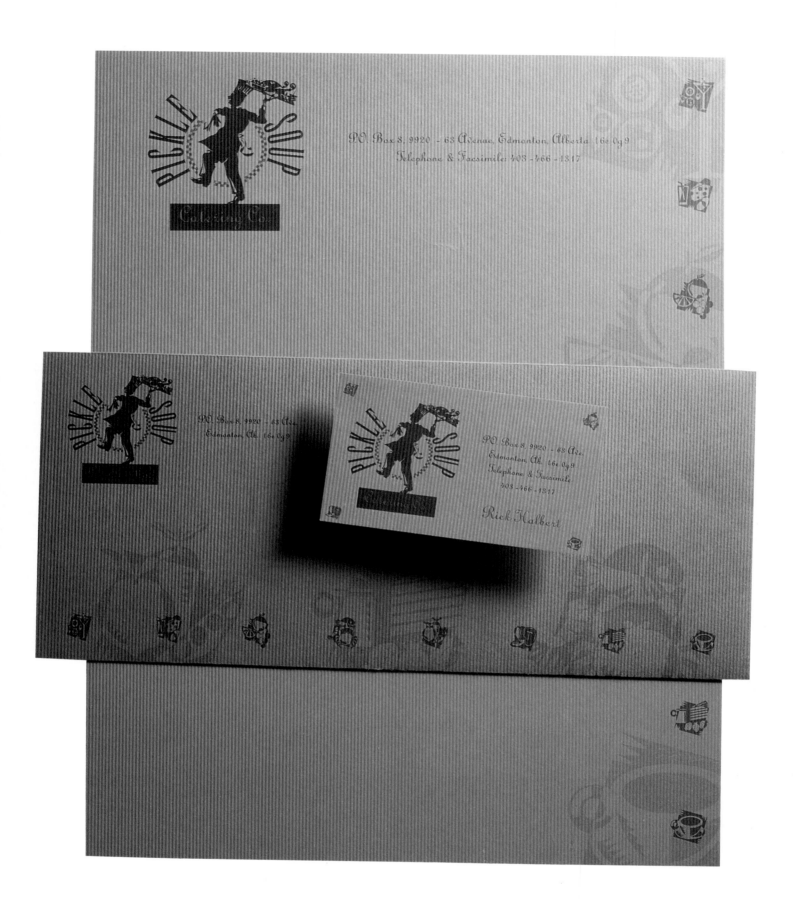

DESIGN FIRM Duck Soup Graphics
ALL DESIGN William Doucette
CLIENT Pickle Soup Catering Co.
PAPER/PRINTING Domtar Naturals, two match colors

Two colors of the same paper stock were used for a visual con-
trast. The hand-drawn logo represents the chef/president who
had built a reputation before starting the catering division.

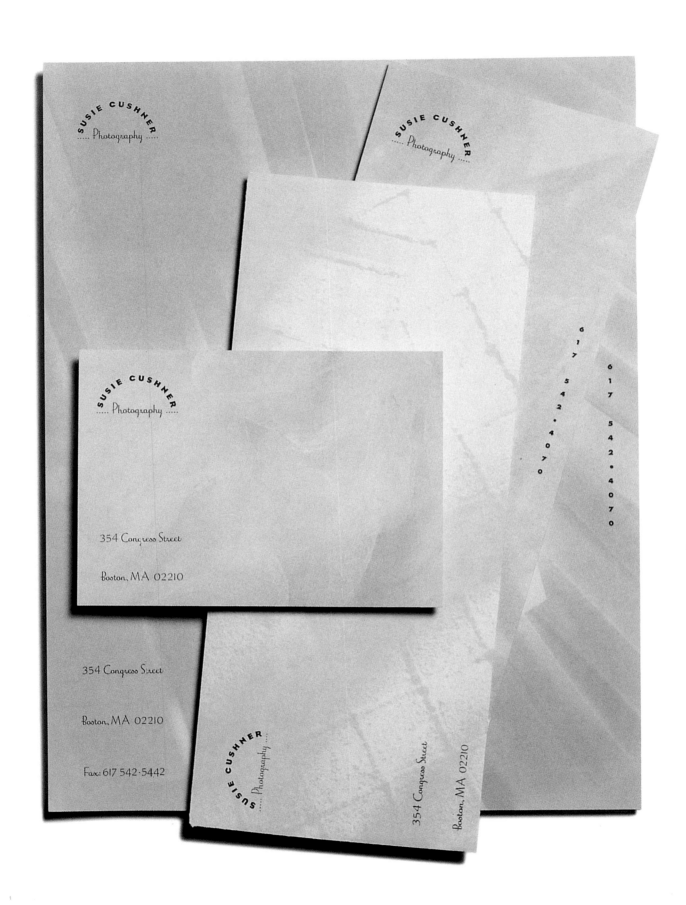

DESIGN FIRM Clifford Selbert Design
ART DIRECTOR Melanie Lowe
DESIGNER Melanie Lowe
CLIENT Susie Cushner Photography
PAPER/PRINTING Strathmore

25

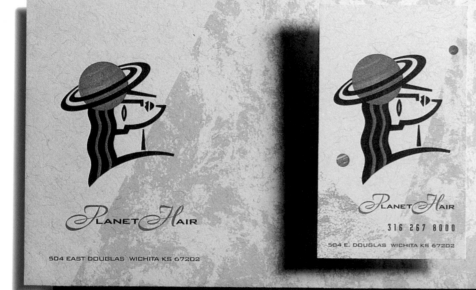

AN AVEDA CONCEPT SALON

504 EAST DOUGLAS WICHITA KS 67202

316 267 8000
504 E. DOUGLAS WICHITA KS 67202

316 267 8000
504 EAST DOUGLAS WICHITA KS 67202

DESIGN FIRM Greteman Group
DESIGNERS Sonia Greteman, Karen Hogan
ILLUSTRATOR Sonia Greteman
CLIENT Planet Hair
PAPER/PRINTING French Rayon
TOOLS Adobe Photoshop, Aldus FreeHand

This unisex logo designed for a hip hair salon is androgynous,
suggesting a cubist feel.

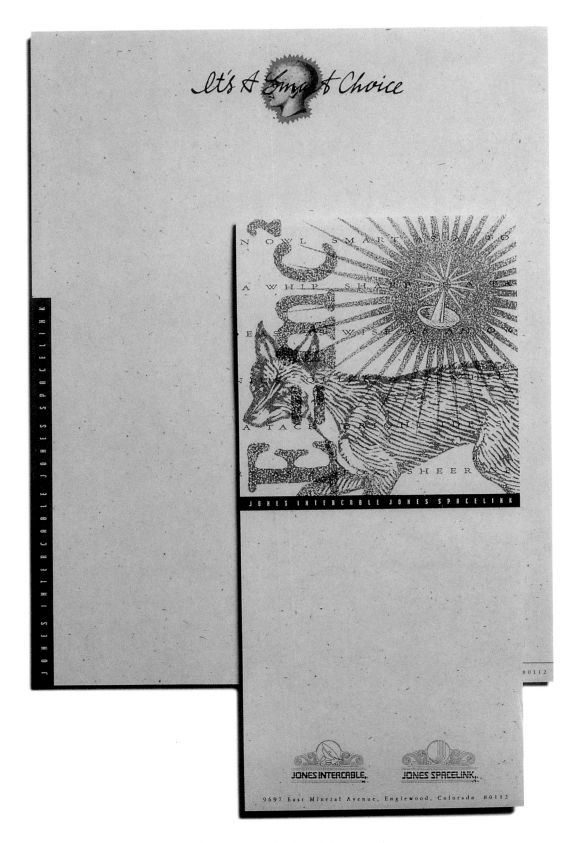

Design Firm Vaughn Wedeen Creative
Art Director Steve Wedeen, Daniel Michael Flynn
Designer Daniel Michael Flynn
Illustrator Bill Gerhold
Client Jones Intercable
Paper/Printing French Speckletone Old Green text.

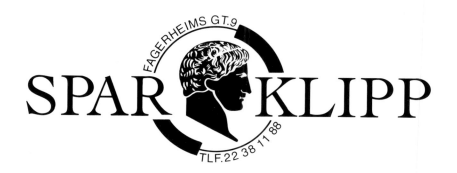

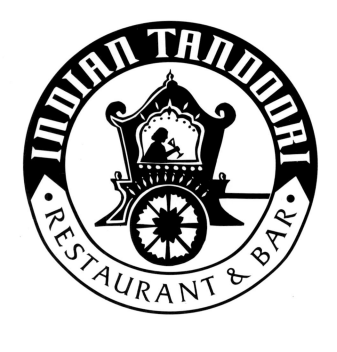

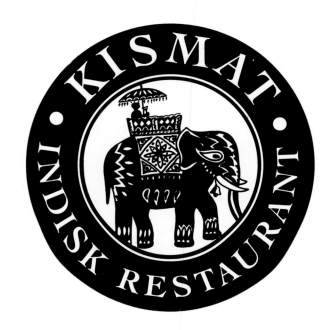

DESIGN FIRM Amar's Design

ALL DESIGN Amar Aziz

CLIENTS Spar Klipp, Indian Tandoori Restaurant & Bar, and
Kismat Indisk Restaurant

TOOL QuarkXPress

···

All the logos were drawn by hand, and all the letters and head-
ings were created in QuarkXPress.

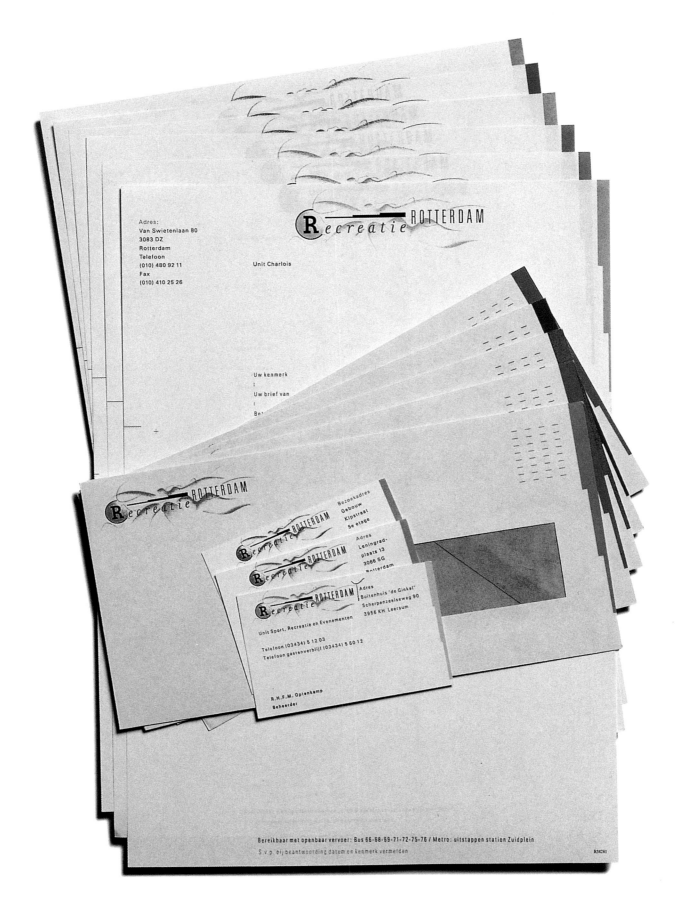

DESIGN FIRM Proforma Rotterdam
ART DIRECTOR Aadvan Pommelen
DESIGNER Gert Jan Rooijakkers
CLIENT Recreative Rotterdam
PAPER/PRINTING Bankpost

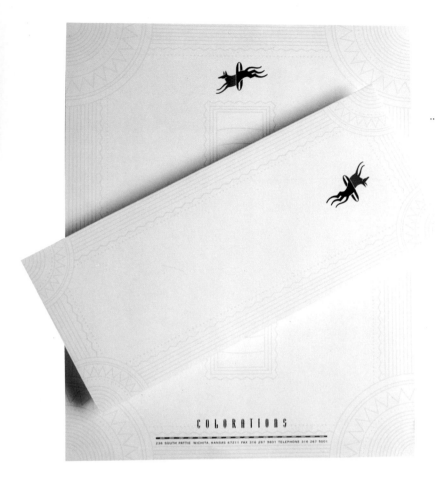

DESIGN FIRM Greteman Group
ART DIRECTOR Sonia Greteman
DESIGNERS Sonia Greteman, Bill Gardner
CLIENT Colorations
PAPER/PRINTING Classic Crest, 4-color process
TOOL Aldus FreeHand

This service bureau jumps through hoops for its clients. The big "C" changes color from black-and-white to magical color creating a circus-like atmosphere.

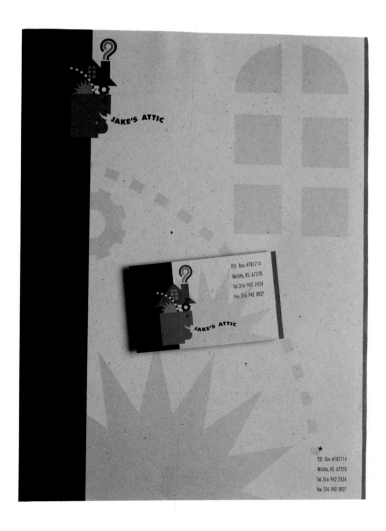

DESIGN FIRM Greteman Group
ART DIRECTOR Sonia Greteman
DESIGNERS Sonia Greteman, Karen Hogan
ILLUSTRATOR Sonia Greteman
CLIENT Jakes Attic Science Show
PAPER/PRINTING Benefit, 4-color process
TOOL Aldus FreeHand

This design displays a fun level of playfulness, curiosity, and excitement while developing a "character" with an attic hat, question-mark smoke, and a sparkle in his eye.

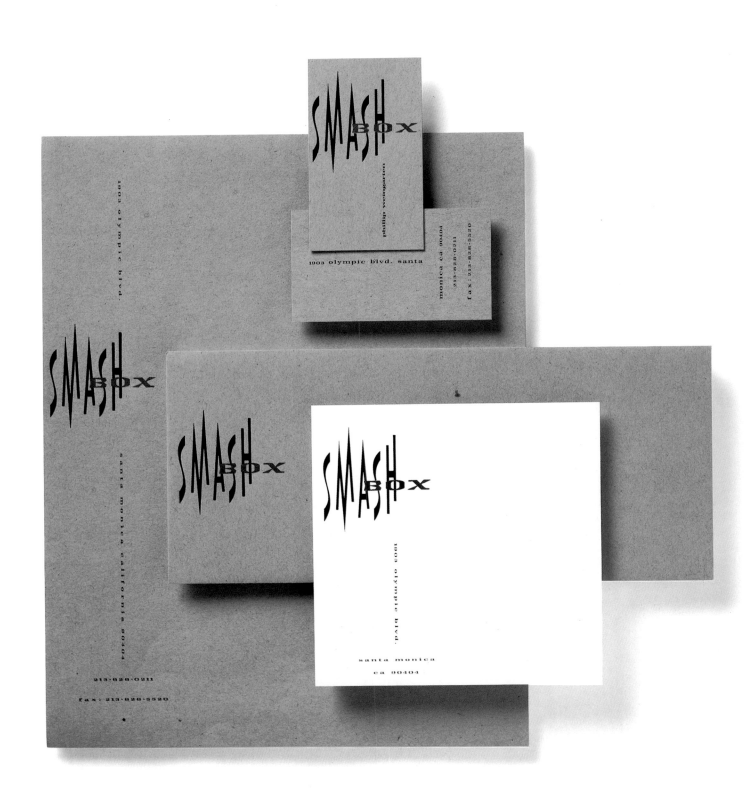

CLIENT Smashbox
DESIGN FIRM Margo Chase Design
ART DIRECTOR Margo Chase
DESIGNER Margo Chase
PAPER/PRINTING Two colors and foil on Speckletone Chipboard

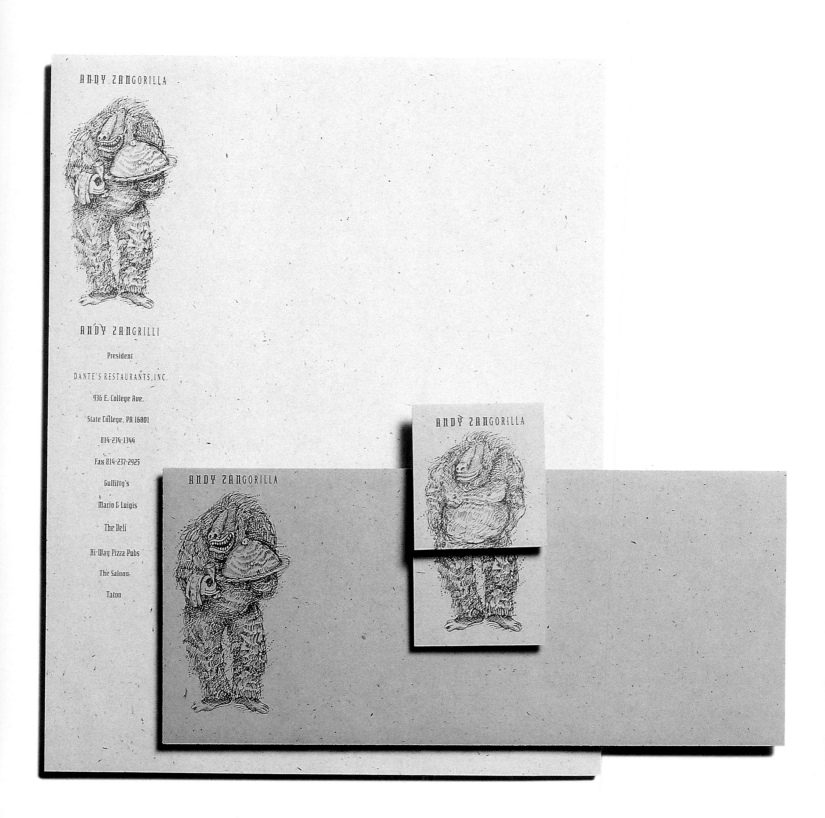

ANDY ZANGORILLA

ANDY ZANGRILLI

President

DANTE'S RESTAURANTS, INC.

936 E. College Ave.

State College, PA 16801

814-234-1344

Fax 814-237-2925

Gullifty's

Mario & Luigis

The Deli

Hi-Way Pizza Pubs

The Saloon

Tatoo

Design Firm Sommese Design

Art Director Lanny Sommese, Kristin Sommese

Designer Kristin Sommese

Illustrator Lanny Sommese

Client Dante's Restaurants Inc., Andy Zangrilli

Paper/Printing Cross Pointe Genesis Script

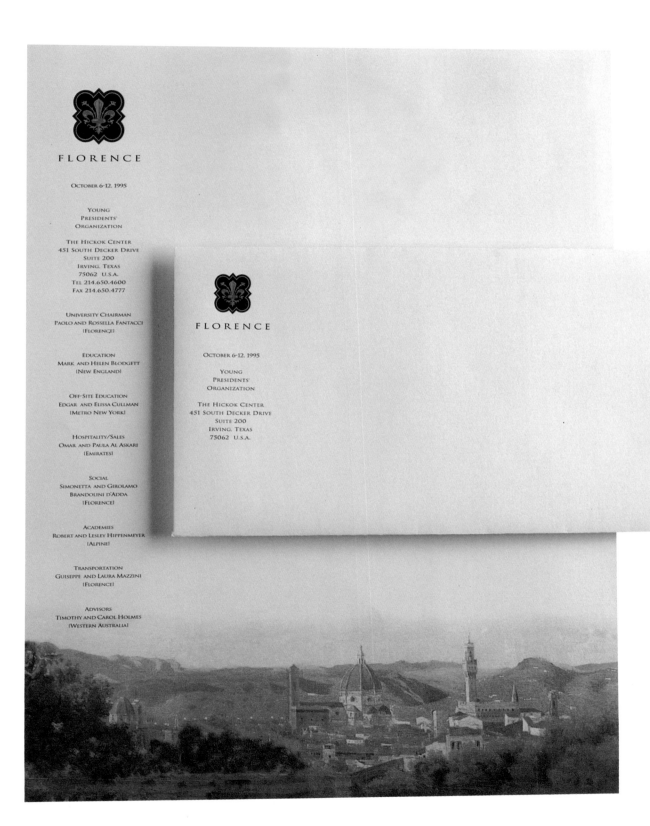

FLORENCE

OCTOBER 6-12, 1995

YOUNG
PRESIDENTS'
ORGANIZATION

THE HICKOK CENTER
451 SOUTH DECKER DRIVE
SUITE 200
IRVING, TEXAS
75062 U.S.A.
TEL 214.650.4600
FAX 214.650.4777

UNIVERSITY CHAIRMAN
PAOLO AND ROSSELLA FANTACCI
[FLORENCE]

EDUCATION
MARK AND HELEN BLODGETT
[NEW ENGLAND]

OFF-SITE EDUCATION
EDGAR AND ELISSA CULLMAN
[METRO NEW YORK]

HOSPITALITY/SALES
OMAR AND PAULA AL ASKARI
[EMIRATES]

SOCIAL
SIMONETTA AND GIROLAMO
BRANDOLINI D'ADDA
[FLORENCE]

ACADEMIES
ROBERT AND LESLEY HIPPENMEYER
[ALPINE]

TRANSPORTATION
GUISEPPE AND LAURA MAZZINI
[FLORENCE]

ADVISORS
TIMOTHY AND CAROL HOLMES
[WESTERN AUSTRALIA]

FLORENCE

OCTOBER 6-12, 1995

YOUNG
PRESIDENTS'
ORGANIZATION

THE HICKOK CENTER
451 SOUTH DECKER DRIVE
SUITE 200
IRVING, TEXAS
75062 U.S.A.

DESIGN FIRM Swieter Design U.S.
ART DIRECTOR John Swieter
DESIGNERS Mark Ford, Jenice Heo
CLIENT Young Presidents' Organization Florence University

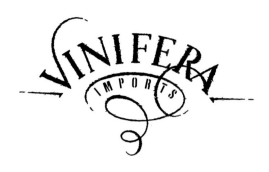

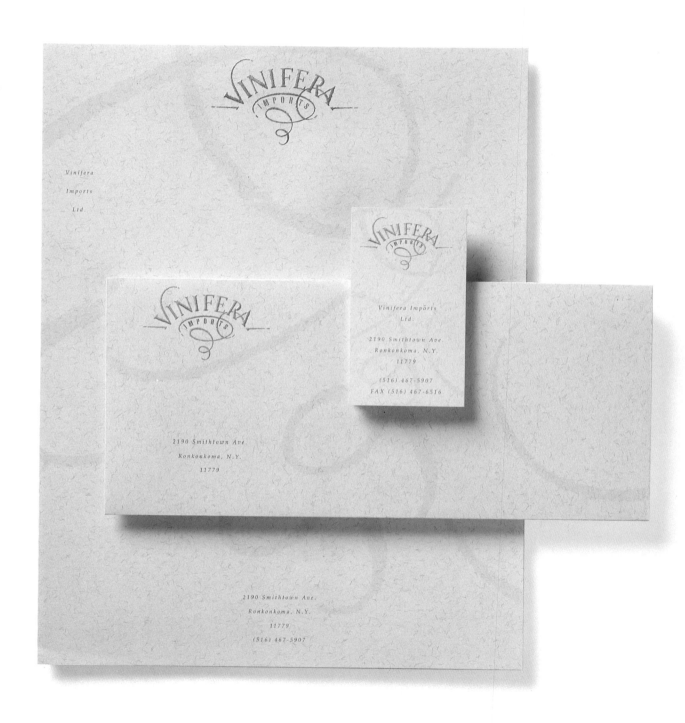

CLIENT Vinfera Imports
DESIGN FIRM Hornall Anderson Design Works
ART DIRECTOR Jack Anderson
DESIGNERS Jack Anderson, David Bates
ILLUSTRATOR David Bates
PAPER/PRINTING Two colors on Tuscan Terra

DESIGN FIRM David Carter Design
ART DIRECTOR David Brashier
DESIGNER David Brashier
CLIENT Disney Orlando, Florida

DESIGN FIRM Luis Fitch Diseño
ART DIRECTOR Luis Fitch
DESIGNER Luis Fitch
CLIENT Picante Restaurant

DESIGN FIRM David Carter Design
ART DIRECTOR Sharon Lejeune
DESIGNER Sharon Lejeune
ILLUSTRATOR Sharon Lejeune
CLIENT Pat Foss

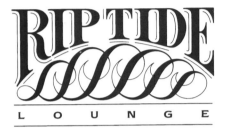

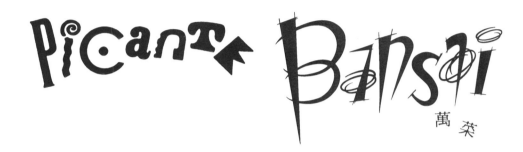

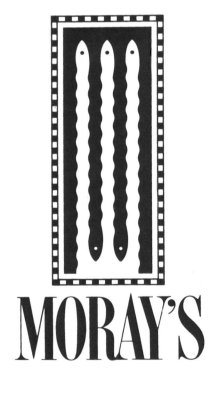

DESIGN FIRM David Carter Design
ART DIRECTOR Gary Lobue
DESIGNER Gary Lobue
ILLUSTRATOR Gary Lobue
CLIENT Moray's Restaurant

DESIGN FIRM David Carter Design
ART DIRECTOR Randall Hill
DESIGNER Randall Hill
ILLUSTRATOR Randall Hill
CLIENT Grand Hyatt, Bali

DESIGN FIRM Sommese Design
ART DIRECTOR Lanny Sommese
DESIGNER Lanny Sommese
ILLUSTRATOR Lanny Sommese
CLIENT Dante's Restaurants Inc.

This is the logo for the
children's menu.

Can be mailed at standard postal rate.

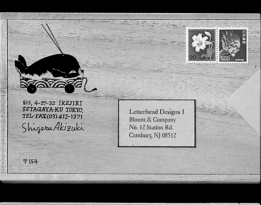

Letterhead Designs 1
Blount & Company
No. 12 Station Rd.
Cranbury, NJ 08512

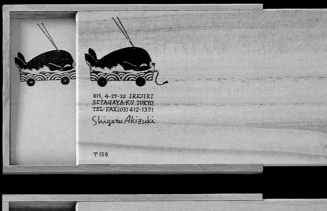

815, 4-27-32 IKEJIRI
SETAGAYA-KU TOKYO,
TEL·FAX(03) 412-1371
Shigeru Akizuki

〒154

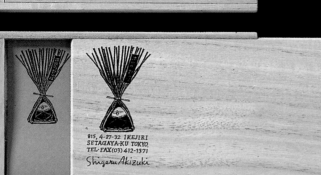

815, 4-27-32 IKEJIRI
SETAGAYA-KU TOKYO,
TEL·FAX(03) 412-1371
Shigeru Akizuki

〒154

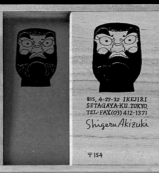

815, 4-27-32 IKEJIRI
SETAGAYA-KU TOKYO,
TEL·FAX(03) 412-1371
Shigeru Akizuki

〒154

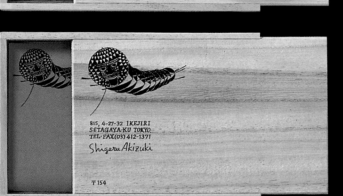

815, 4-27-32 IKEJIRI
SETAGAYA-KU TOKYO,
TEL·FAX(03) 412-1371
Shigeru Akizuki

〒154

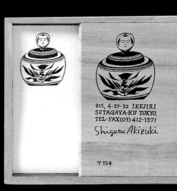

815, 4-27-32 IKEJIRI
SETAGAYA-KU TOKYO,
TEL·FAX(03) 412-1371
Shigeru Akizuki

〒154

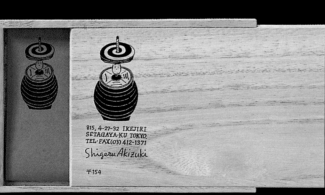

815, 4-27-32 IKEJIRI
SETAGAYA-KU TOKYO,
TEL·FAX(03) 412-1371
Shigeru Akizuki

〒154

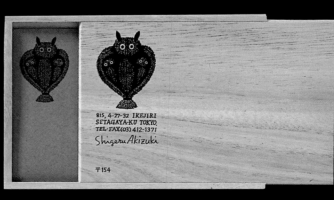

815, 4-27-32 IKEJIRI
SETAGAYA-KU TOKYO,
TEL·FAX(03) 412-1371
Shigeru Akizuki

〒154

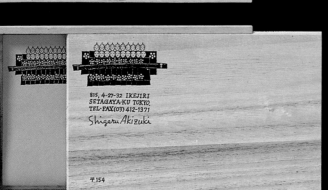

815, 4-27-32 IKEJIRI
SETAGAYA-KU TOKYO,
TEL·FAX(03) 412-1371
Shigeru Akizuki

〒154

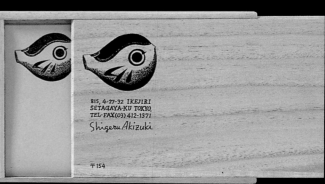

815, 4-27-32 IKEJIRI
SETAGAYA-KU TOKYO,
TEL·FAX(03) 412-1371
Shigeru Akizuki

〒154

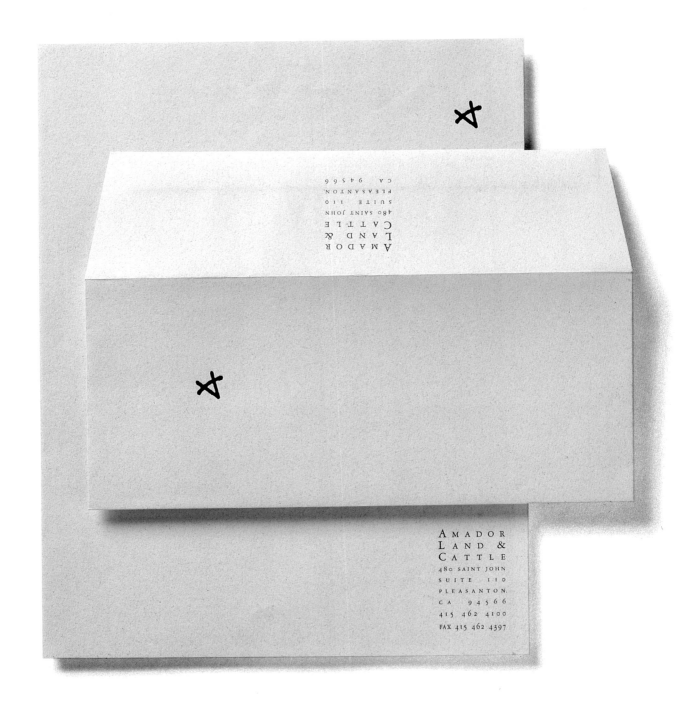

CLIENT Amador Land & Cattle

DESIGN FIRM Communication Arts Inc.

ART DIRECTOR Henry Beer

DESIGNER David A. Shelton

PAPER/PRINTING Two colors on Speckletone Ivory White Text

A F T E R | H O U R S

C R E A T I V E

6 0 2

P 2 5 6 2 6 4 8 | F 2 5 6 6 4 2 2

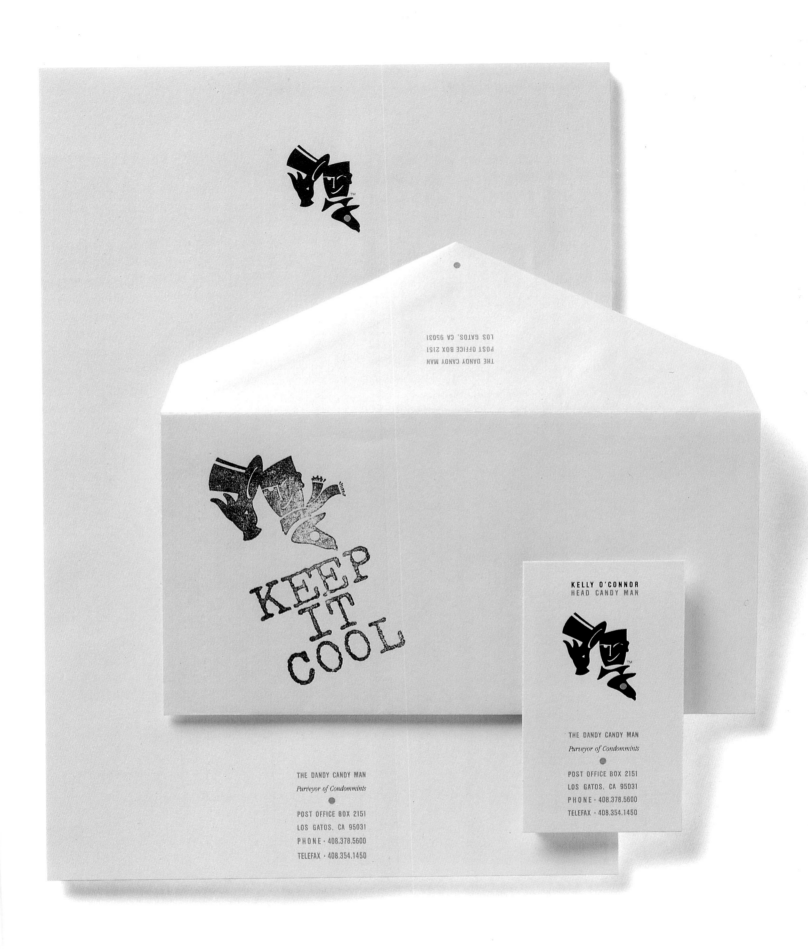

CLIENT The Dandy Candy Man
DESIGN FIRM Tharp Did It ° Los Gatos/San Francisco
ART DIRECTOR Rick Tharp
DESIGNER Rick Tharp
ILLUSTRATOR Kim Tomlinson
PAPER/PRINTING Two colors on Strathmore Writing

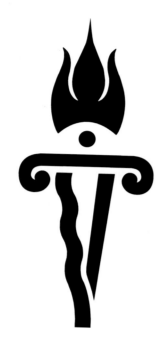

Design Firm Pinto Design
Designer John Pinto
Tool Adobe Illustrator

Design Firm Greteman Group
Art Director/Designer Sonia Greteman
Client Winning Visions

In this logo for an advertising firm, the torch forms a "V," and the flame forms an eye.

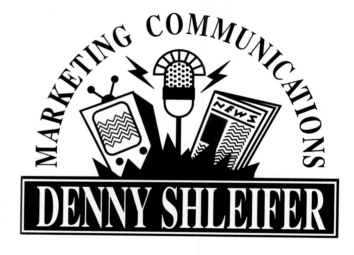

IVIE & ASSOCIATES, INC.
MARKETING COMMUNICATIONS

Design Firm Jeff Fisher Design
All Design Jeff Fisher
Client Denny Shleifer Marketing Communications

The FreeHand illustrations of a television, radio mike and newspaper breaking through the surface convey enthusiasm and excitement.

Design Firm Ivie & Associates Inc.
All Design Jeff Taylor
Client Ivie & Associates, Inc.
Tool QuarkXPress

The ivy leaf was hand-illustrated, then scanned and imported into a QuarkXPress document, where type was added.

CLIENT Tracy Sabin

DESIGN FIRM Tracy Sabin, Illustration & Design

DESIGNER Tracy Sabin

PAPER/PRINTING All pieces printed on French Speckleton
Stationery: Three colors on Chalk White Text.
Business Card: Two colors on Grenable Gray Cover.
Envelopes: One color on Briquet Text.

Tracy Sabin

ILLUSTRATION & DESIGN

TRACY SABIN
ILLUSTRATION & DESIGN
13476 RIDLEY RD.
SAN DIEGO, CA 92129

TRACY SABIN
ILLUSTRATION & DESIGN
13476 RIDLEY RD
SAN DIEGO, CA 92129
(619) 484-8712

TRACY SABIN, ILLUSTRATION & DESIGN / 13476 RIDLEY RD., SAN DIEGO, CA 92129 / (619) 484-8712

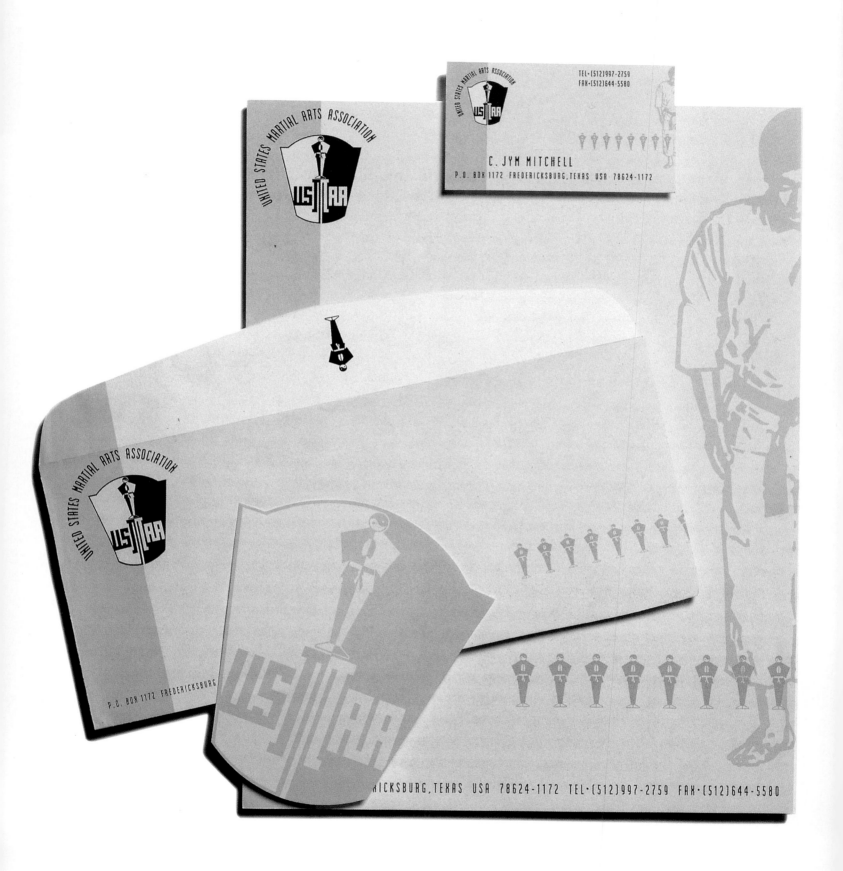

DESIGN FIRM Romeo Empire Design

ART DIRECTOR Vincent Romeo

DESIGNER Vincent Romeo

ILLUSTRATOR Vincent Romeo

CLIENT United States Martial Arts Association

PAPER/PRINTING Mohawk Superfine

CLIENT Hogeschool voor de Kunsten Utrecht
DESIGN FIRM Samenwerkende Ontwerpers
DESIGNER Jan Paul de Vries
ART DIRECTOR Andre' Toet

CLIENT K2 Skis
DESIGN FIRM Hornall Anderson Design Works
DESIGNERS Jack Anderson, Jani Drewfs, David Bates
ART DIRECTOR Jack Anderson

CLIENT Dante's Restaurant, Inc.
DESIGN FIRM Lanny Sommese Design
DESIGNER Kristin Breslin
ART DIRECTOR Lanny Sommese

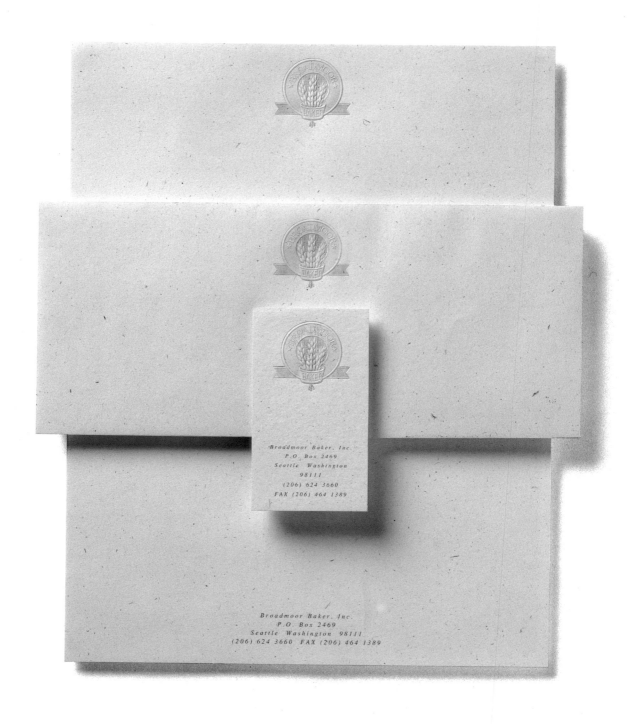

Broadmoor Baker, Inc.
P.O. Box 2469
Seattle Washington
98111
(206) 624 3660
FAX (206) 464 1389

Broadmoor Baker, Inc.
P.O. Box 2469
Seattle Washington 98111
(206) 624 3660 FAX (206) 464 1389

CLIENT Broadmoor Baker
DESIGN FIRM Homall Anderson Design
ART DIRECTOR Jack Anderson
DESIGNERS Jack Anderson, Mary Hermes
PAPER/PRINTING One color on Speckleton

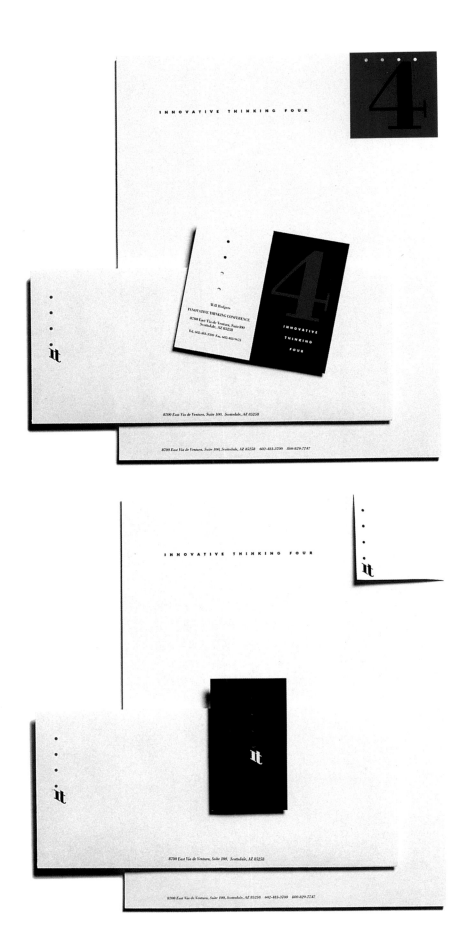

DESIGN FIRM Ortega Design Studio

ART DIRECTOR Joann Ortega, Susann Ortega

DESIGNER Susann Ortega, Joann Ortega

ILLUSTRATOR Susann Ortega

TYPE DESIGN Joann Oretga

CLIENT Quindeca Corporation

PAPER/PRINTING Enhance, foil stamp, emboss/deboss

FAX 432-7713

(515) 432-7700

P.O. BOX 367

BOONE, IOWA 50036

P.O. BOX 367

BOONE, IOWA 50036

DR. SHEILA MCGUIRE

MEDICAL SCIENTIST

P.O. BOX 367

BOONE, IOWA 50036

(515) 432-7700

FAX 432-7713

DESIGN FIRM Creative EDGE
DESIGNER Rick Salzman, Barbara Pitfido
CLIENT Schenck Chiropractic
PAPER/PRINTING Strathmore Renewal

CLIENT Asymetrix Corporation
DESIGN FIRM Hornall Anderson Design Works
DESIGNERS Jack Anderson, Juliet Shen, Heidi Hatlestad
ART DIRECTOR Jack Anderson

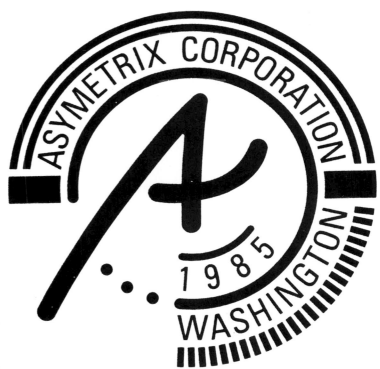

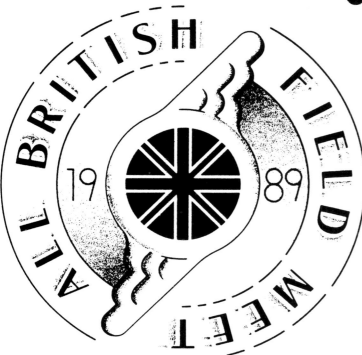

CLIENT All British Field Meet
DESIGN FIRM Hornall Anderson Design Works
DESIGNERS Jack Anderson, David Bates
ART DIRECTOR Jack Anderson

CLIENT Studio 904 Mayor's Award
DESIGN FIRM Hornall Anderson Design Works
DESIGNERS Juliet Shen, Heidi Hatlestad
ART DIRECTOR Juliet Shen

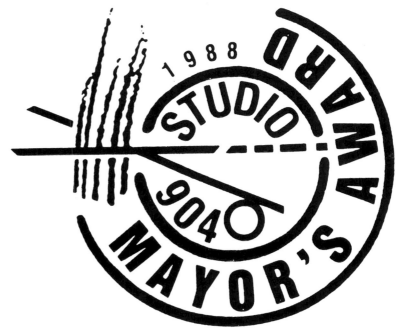

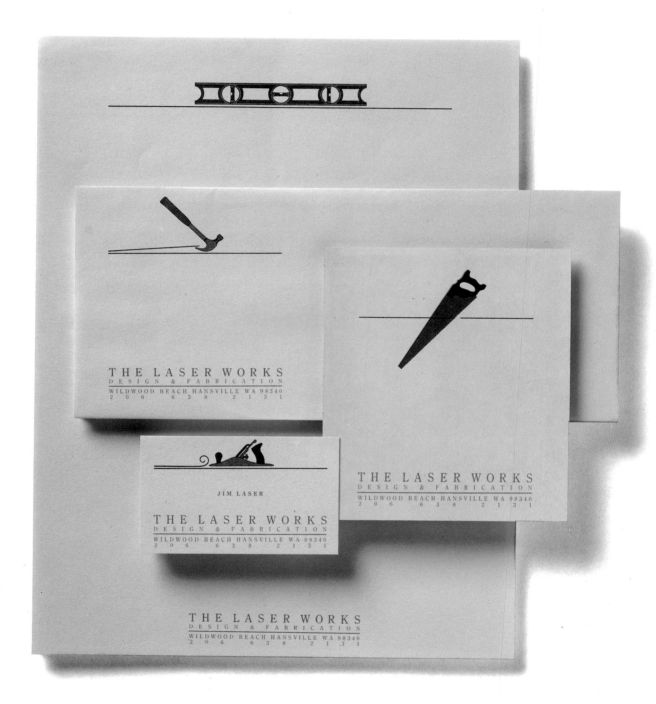

THE LASER WORKS
DESIGN & FABRICATION
WILDWOOD BEACH HANSVILLE WA 98340
2 0 6 6 3 8 2 1 3 1

JIM LASER

THE LASER WORKS
DESIGN & FABRICATION
WILDWOOD BEACH HANSVILLE WA 98340
2 0 6 6 3 8 2 1 3 1

THE LASER WORKS
DESIGN & FABRICATION
WILDWOOD BEACH HANSVILLE WA 98340
2 0 6 6 3 8 2 1 3 1

CLIENT The Laserworks
DESIGN FIRM Hornall Anderson Design Works
ART DIRECTOR Jack Anderson
DESIGNERS Jack Anderson, Cliff Chung
PAPER/PRINTING Two colors on Strathmore

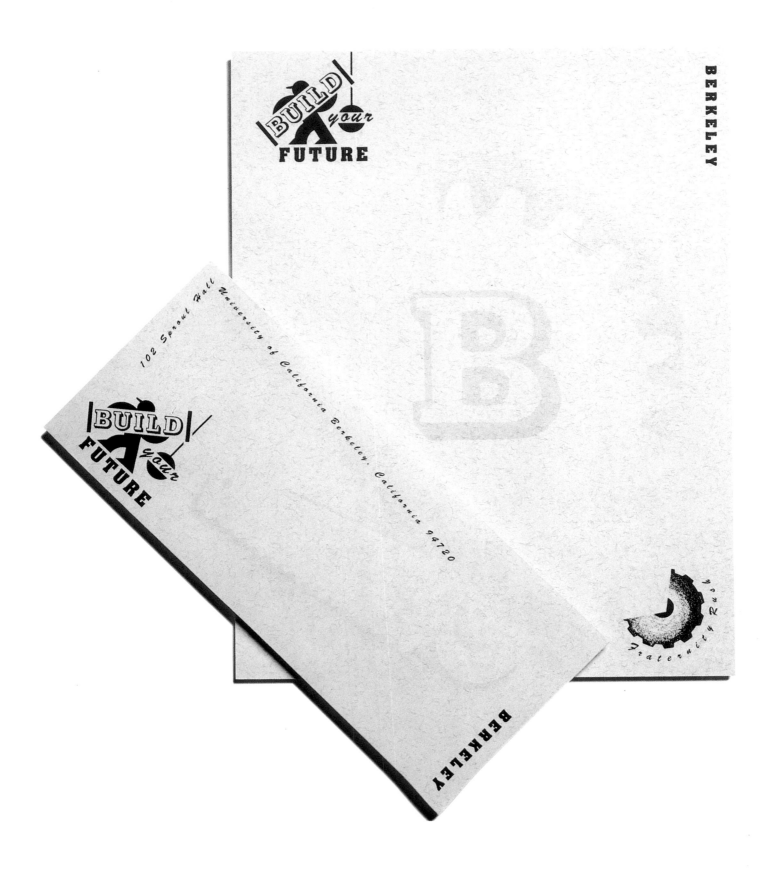

DESIGN FIRM Sayles Graphic Design

ART DIRECTOR John Sayles

DESIGNER John Sayles

ILLUSTRATOR John Sayles

CLIENT University of California, Berkeley

PAPER/PRINTING James River, Tuscan Terra Gray, 2 colors

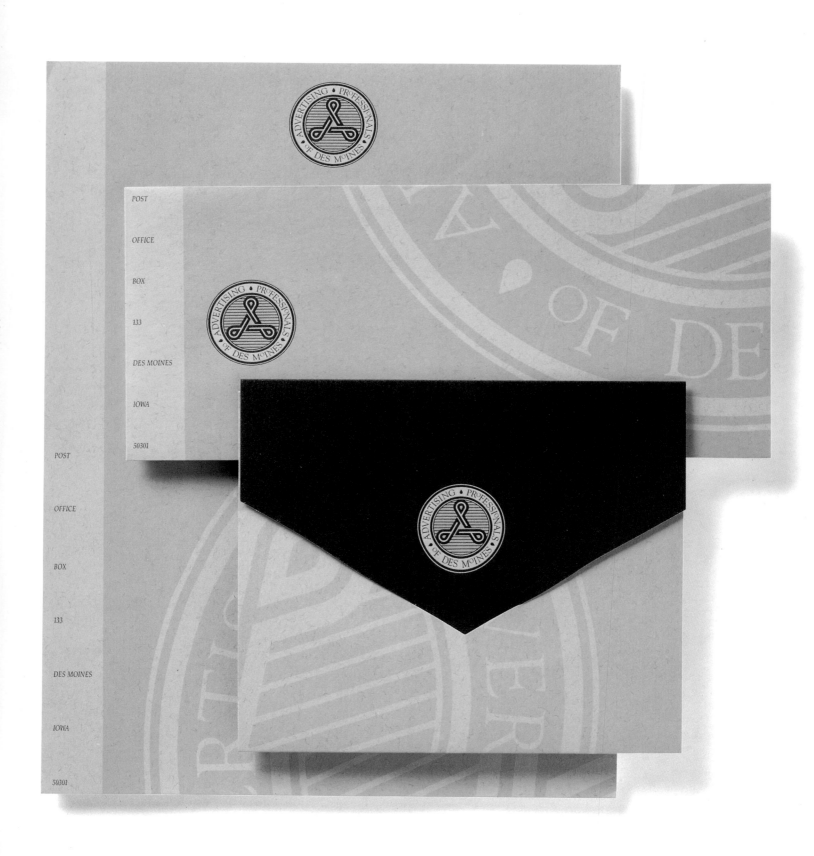

CLIENT Advertising Professionals of Des Moines
DESIGN FIRM Sayles Graphic Design
ART DIRECTOR John Sayles
DESIGNER John Sayles
PAPER/PRINTING Two colors on James River Tuscan Terra

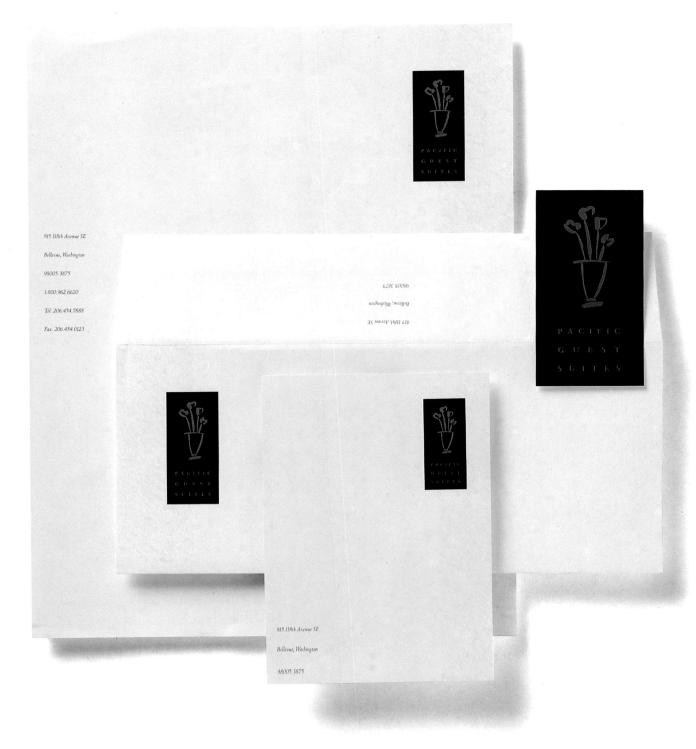

CLIENT Pacific Guest Suites
DESIGN FIRM Hornall Anderson Design Works
ART DIRECTOR Julia LaPine
DESIGNER Julia LaPine
ILLUSTRATOR Julia LaPine
PAPER/PRINTING Two colors on Crane's Crest

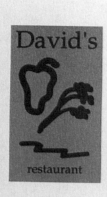

123 Stuart Street

Boston, MA 02116

617•367•8405

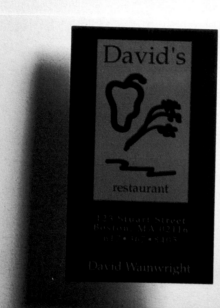

123 Stuart Street

Boston, MA 02116

617•367•8405

DESIGN FIRM Brenner Design
ALL DESIGN Martha B. Slone
CLIENT David's Restaurant
PAPER/PRINTING Strathmore Renewal Recycled Text, 2-color
TOOL Aldus FreeHand

The design was created by drawing quick sketches of vegetables
and wheat and adjusting the line width. Palatino was chosen for
its versatility, and paper was chosen to complement ink.

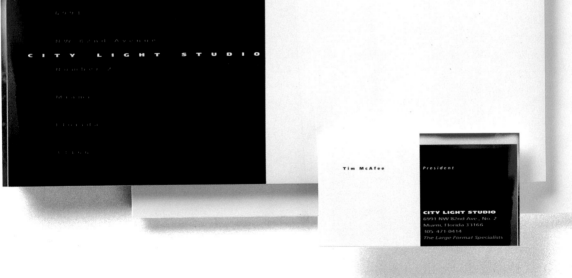

CLIENT City Light Studio

DESIGN FIRM Urban Taylor & Associates

ART DIRECTOR Alan Urban

DESIGNER Alan Urban

ILLUSTRATOR Alan Urban

PAPER/PRINTING Four color process on Consolidated Frostbite

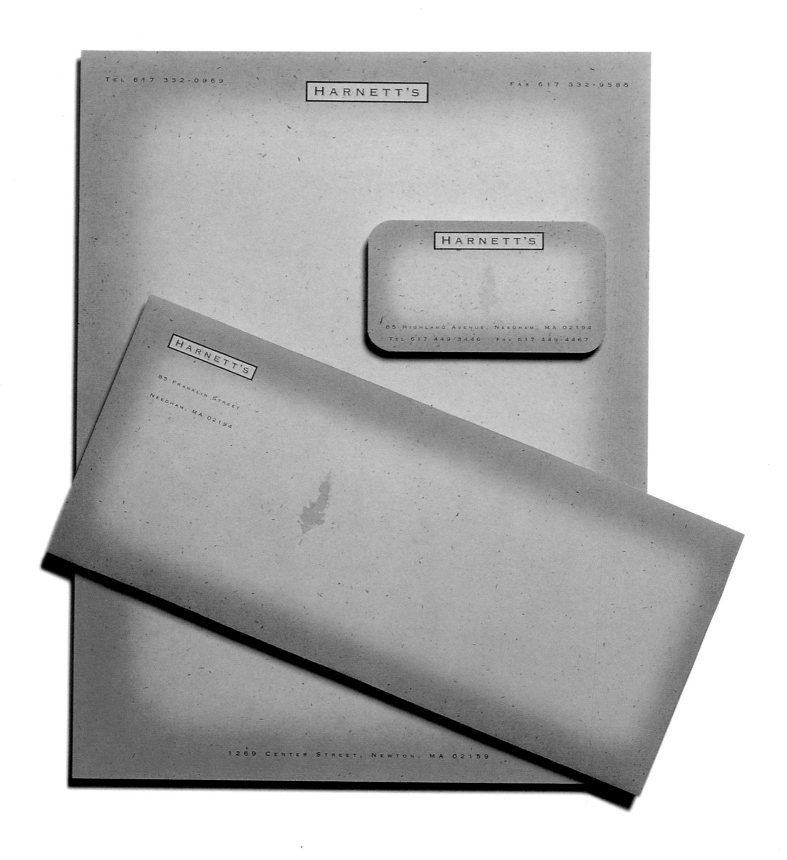

DESIGN FIRM Clifford Selbert Design
ART DIRECTOR Melanie Lowe
DESIGNER Melanie Lowe
CLIENT Harnett's
PAPER/PRINTING Champion Benefit

Design Firm Greteman Group
Art Directors/Designers Sonia Greteman,
James Strange
Client City of Wichita

...

The logo for Wichita's Fair + Festival used a festive character
to capture the feeling of the event.

Design Firm Sibley/Peteet Design
Art Director/Designer David Beck
Illustrators David Beck, Mike Broshous
Client Charles James
Tool Adobe Illustrator

...

The final design was done in Illustrator from a scan from a
pencil drawing. Crack-and-peel stickers were created to give
to Charles James's clients.

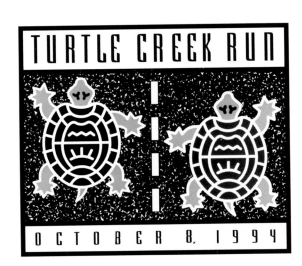

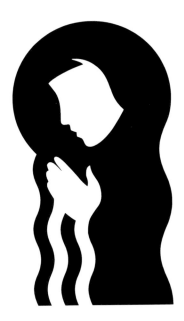

Design Firm Sibley/Peteet Design
Art Director Donna Aldridge
Designer Donna Aldridge
Client American Heart Association
Tool Adobe Illustrator and Photoshop

...

The background texture for the pavement began as a photo-
copy from an old schoolbook, which was then manipulated on
the photocopier and by hand, then scanned into Photoshop.

Design Firm Greteman Group
Art Directors/Designers Sonia Greteman,
James Strange
Client Our Lady of Lourdes

...

This logo is for a rehabilitation hospital representing the Patron
Saint of Our Lady of Lourdes and her healing attributes.

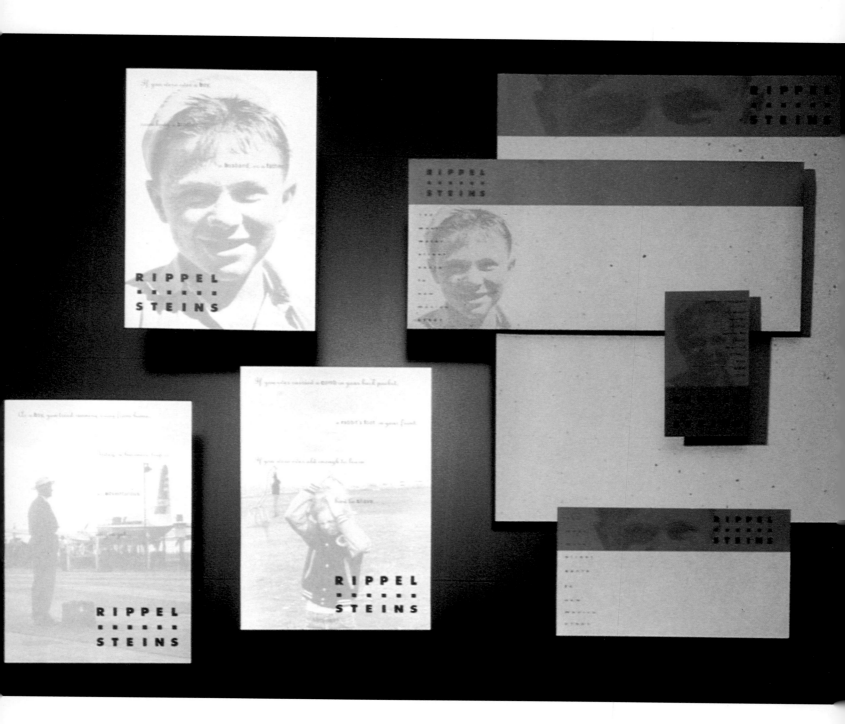

Design Firm Vaughn Wedeen Creative
Art Director/Designer Rick Vaughn
Client Rippelstein's
Paper/Printing Confetti, Academy Printing
Tools Aldus FreeHand, QuarkXPress

The '50s photo of a small, freckle-faced boy represents the little
boy in everyone. The photo was scanned, retouched in
Photoshop, and screened back using a large dot pattern.

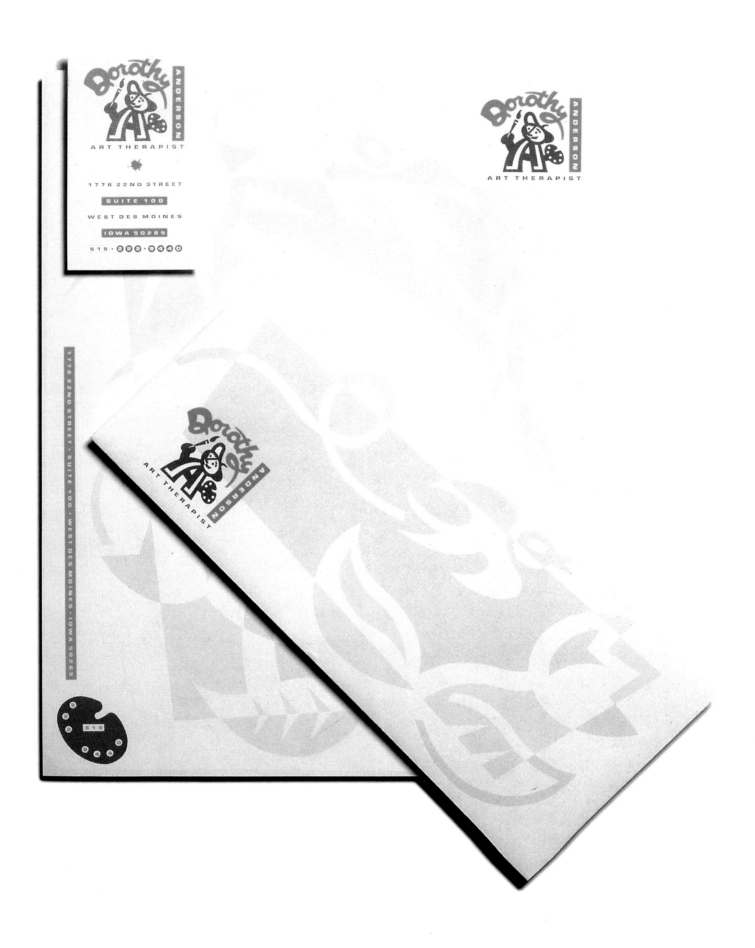

DESIGN FIRM Sayles Graphic Design

ART DIRECTOR John Sayles

DESIGNER John Sayles

ILLUSTRATOR John Sayles

CLIENT Dorothy Anderson, Art Therapist

PAPER/PRINTING Gilbert Paper, White, 2 colors

DESIGN FIRM Jon Flaming Design
ALL DESIGN Jon Flaming
CLIENT Objex Inc.
TOOL Adobe Illustrator

This logo was created for private-label coffees from Objex Inc.

DESIGN FIRM Jon Flaming Design
ALL DESIGN Jon Flaming
TOOL Adobe Illustrator

This logo was created for a design and illustration studio located in the industrial sector of downtown Dallas, next to a huge power plant with tan smokestacks.

DESIGN FIRM Jon Flaming Design
ALL DESIGN Jon Flaming
CLIENT Blockbuster Video
TOOL Adobe Illustrator

Many logos and icons were produced for an elaborate and extensive new business pitch that was made to Blockbuster Video.

DESIGN FIRM Jon Flaming Design
ALL DESIGN Jon Flaming
CLIENT Target Music Research
TOOL Adobe Illustrator

This logo was created for a company that does target market research for the music industry.

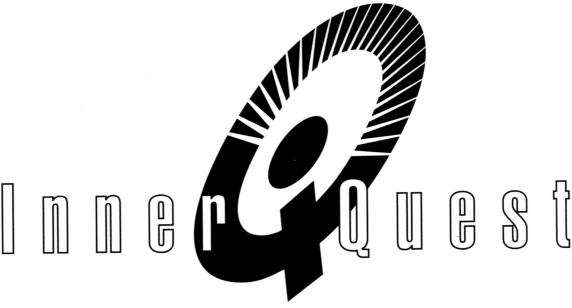

Inner Quest

DESIGN Charles E. Carpenter for Charles Carpenter Design Studio

PROJECT Inner Quest logo

CLIENT Inner Quest

TOOLS Adobe Illustrator

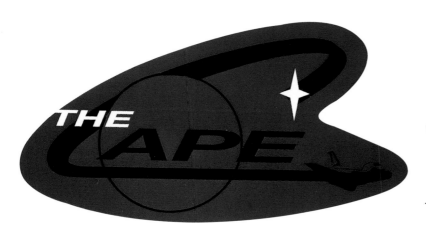

DESIGN Mike Salisbury and Mick Haggerty for Mike Salisbury Communications, Inc.

PROJECT The Cape logo

CLIENT MTM Entertainment

TOOLS Adobe Illustrator on Macintosh

This logo was developed for a new television drama focusing on characters involved in space programs.

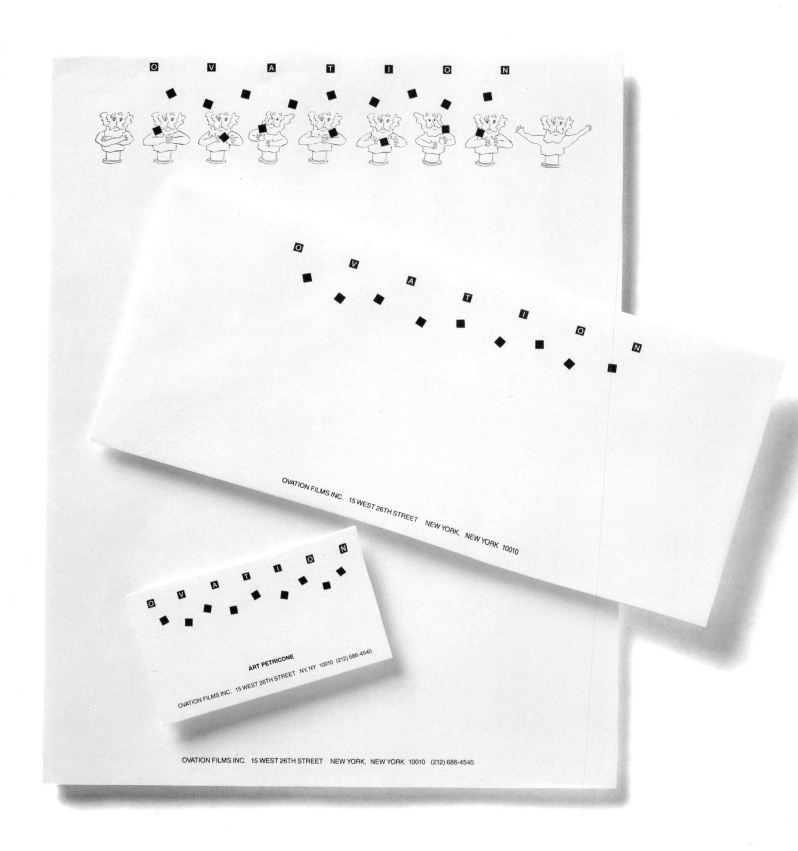

CLIENT Ovation Animation
DESIGN FIRM Frank D'Astolfo Design
ART DIRECTOR Frank D'Astolfo
DESIGNER Frank D'Astolfo
PAPER/PRINTING Two colors on Strathmore Writing

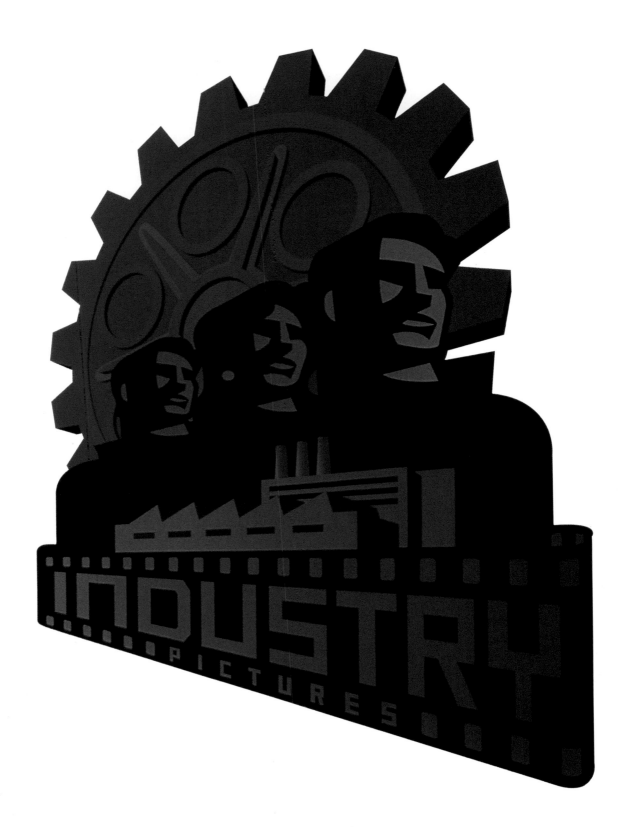

DESIGN Jose Serrano and Tracy Sabin for Mires Design
PROJECT Industry Pictures logo
CLIENT Industry Pictures
TOOLS Adobe Illustrator, Dimensions on Macintosh
FONT Custom Font

This is the logo for a corporate-oriented film company.

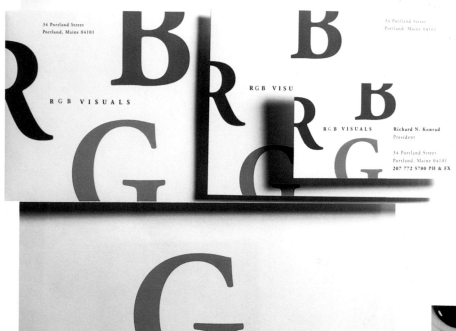

34 Portland Street
Portland, Maine 04101

207 772 5700 PH & FX

R G B V I S U A L S

DESIGN FIRM Thomas Hillman Design
ART DIRECTOR/DESIGNER Thomas Hillman
CLIENT RGB Visuals
TOOL Aldus PageMaker

Three letters—RGB—offer the name and color concept in an overstated and dramatic presentation on a white sheet to enhance colors. The final stationery package was assembled in PageMaker.

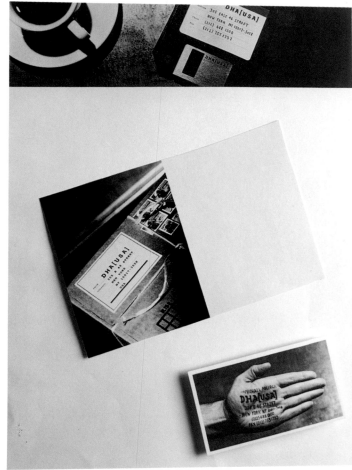

DESIGN FIRM Sagmeister Inc.
ART DIRECTOR/DESIGNER Stefan Sagmeister
PHOTOGRAPHER Tom Schierlitz
CLIENT DHA (USA)
PAPER/PRINTING Strathmore Opaque Bond

DHA (USA) is a consulting company whose services are difficult to pin down. For the identity system, photographs containing all the information demonstrate the services

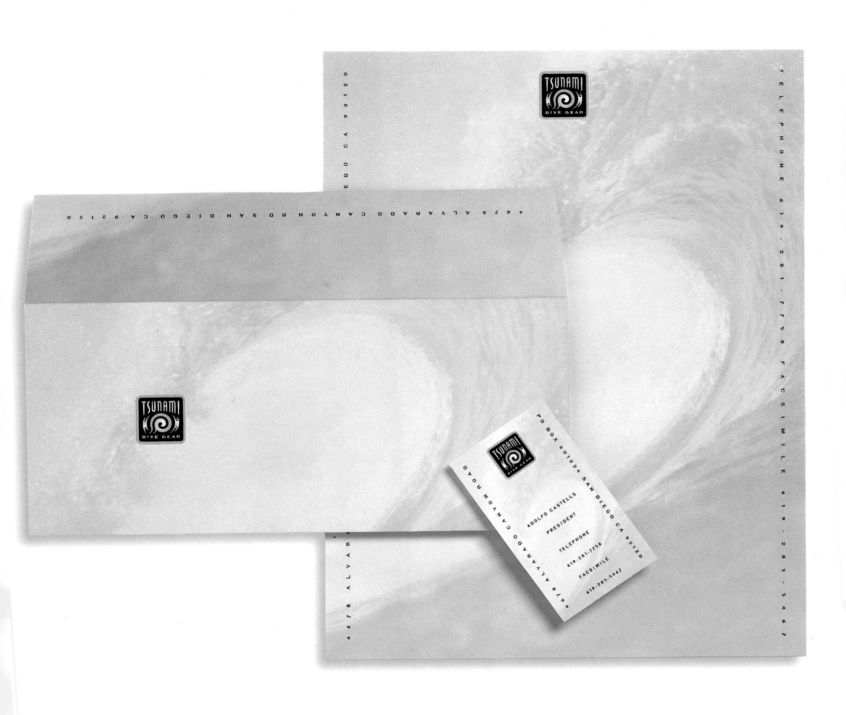

DESIGN John Ball and Deborah Horn for
Mires Design, Inc.
PROJECT Tsunami logo
CLIENT Tsunami Dive Gear
TOOLS Adobe Illustrator on Macintosh

This is a logo for a scuba-diving product line.

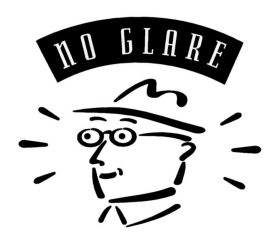

DESIGN FIRM Jon Flaming Design
ALL DESIGN Jon Flaming
CLIENT Eyemasters
TOOL Adobe Illustrator

This logo for no-glare eyewear was created using Illustrator's Brush tool and a Wacom graphics tablet and pen.

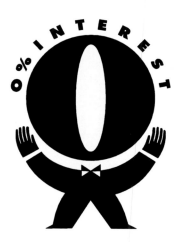

DESIGN FIRM Jon Flaming Design
ALL DESIGN Jon Flaming
CLIENT Computer City
TOOL Adobe Illustrator

This logo was used in a computer store's zero percent interest ad.

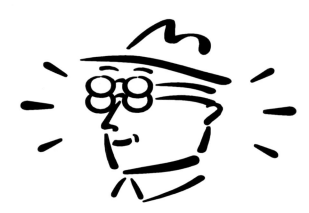

DESIGN FIRM Jon Flaming Design
ALL DESIGN Jon Flaming
CLIENT Eyemasters
TOOL Adobe Illustrator

This logo for Eyemasters's two-for-one sale was created using Illustrator's Brush tool and a Wacom graphics tablet and pen.

DESIGN FIRM Jon Flaming Design
ALL DESIGN Jon Flaming
CLIENT Blockbuster Video
TOOL Adobe Illustrator

Many logos and icons were produced for an elaborate and extensive new business pitch that was made to Blockbuster Video.

CLIENT Zork Inc.
DESIGN FIRM Tracy Sabin, Illustration & Design
DESIGNER Tracy Sabin
PAPER/PRINTING Stationery: Two colors on 70-lb. Avon
Brilliant White Classic Crest Text, Business Card: two colors
on 80-lb. Avon Brilliant White Classic Crest Cover;
Envelope. One color on 60-lb Astrobrite Neptune Blue

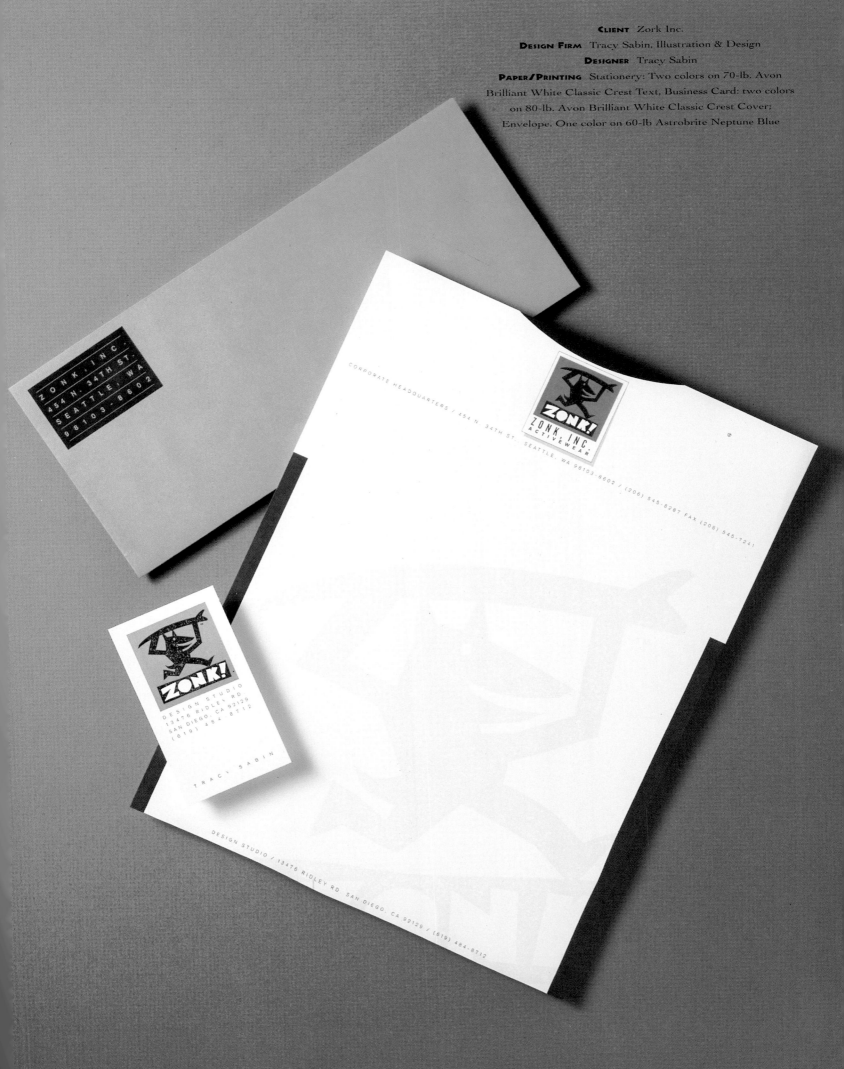

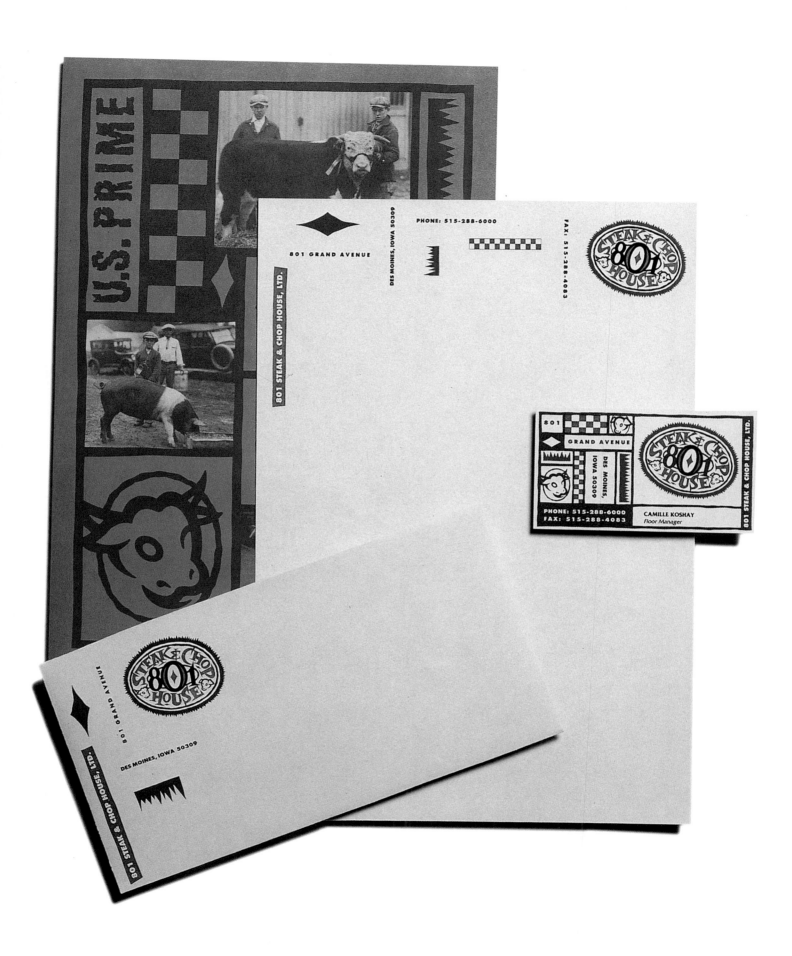

DESIGN FIRM Sayles Graphic Design

ART DIRECTOR John Sayles

DESIGNER John Sayles

ILLUSTRATOR John Sayles

CLIENT 801 Steak & Chop House

PAPER/PRINTING James River, Retreeve Tan, 2 colors

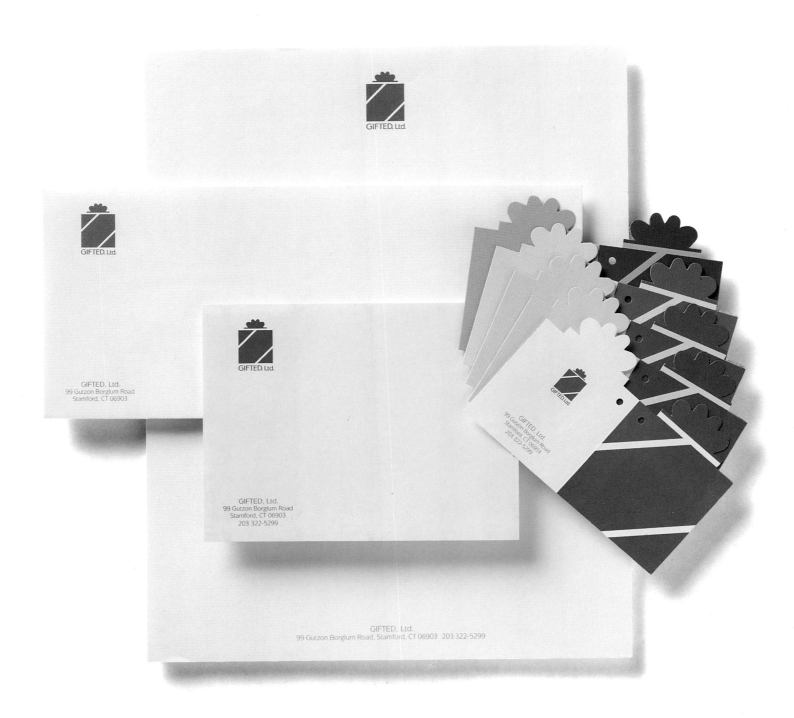

CLIENT Gifted Ltd.
DESIGN FIRM Friday Saturday Sunday, Inc.
DESIGNER Linda Casale
ILLUSTRATOR Linda Casale
PAPER/PRINTING Two colors on Gilbert Oxford

DESIGN FIRM Swieter Design U.S.
ART DIRECTOR John Swieter
DESIGNER Mark Ford
CLIENT Miller Aviation
TOOL Adobe Illustrator

DESIGN FIRM Swieter Design U.S.
ART DIRECTOR John Swieter
DESIGNER Julie Poth
CLIENT Dallas Mavericks
TOOL Adobe Illustrator

DESIGN FIRM Swieter Design U.S.
ART DIRECTOR John Swieter
DESIGNER Mark Ford
CLIENT Sports Lab Inc.
TOOL Adobe Illustrator

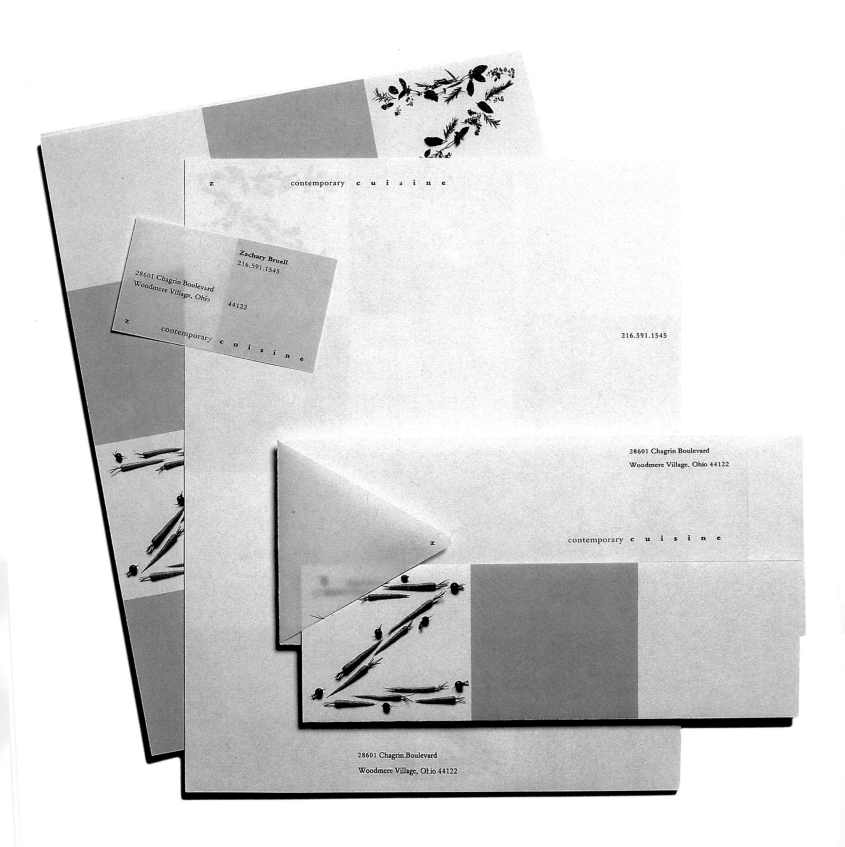

DESIGN FIRM Nesnadny & Schwartz
ART DIRECTOR Joyce Nesnadny, Mark Schwartz
DESIGNER Joyce Nesnadny
CLIENT Z Contemporary Cuisine
PAPER/PRINTING Crane's (letterhead), Neenah (envelope, 2/2)

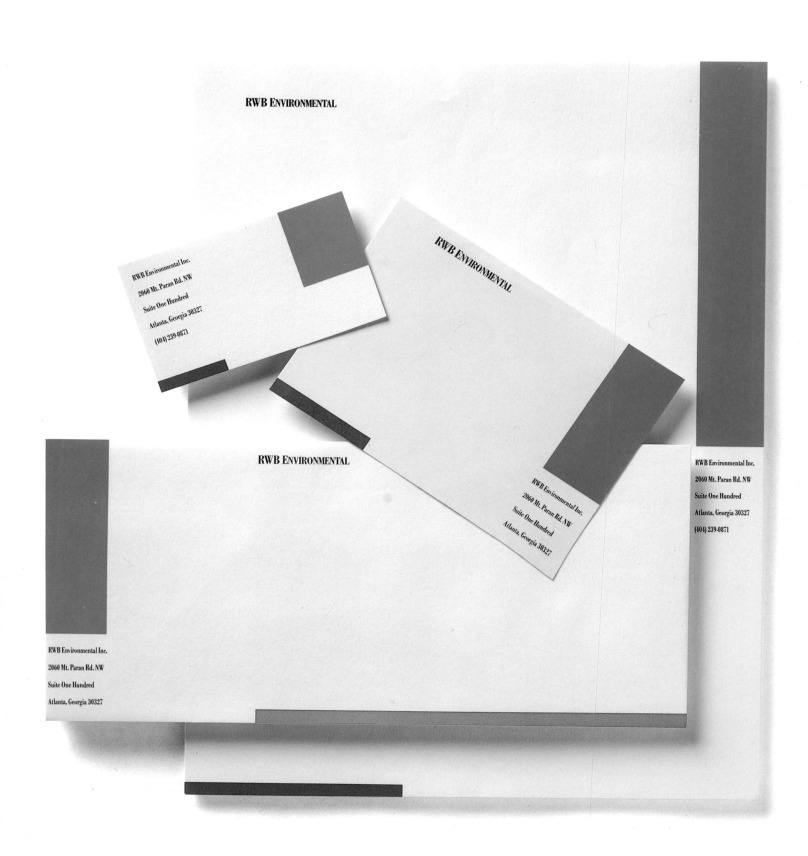

CLIENT RWB Environmental
DESIGN FIRM Rousso+Associates Inc.
ART DIRECTOR Steve Rousso
DESIGNER Steve Rousso
PAPER/PRINTING Three colors on Strathmore Writing

CLIENT Sunrise Preschool
DESIGN FIRM Richardson or Richardson
DESIGNERS Forrest Richardson, Valerie Richardson
ART DIRECTORS Forrest Richardson, Valerie Richardson
PAPER/PRINTING Two colors on 28-lb. Strathmore Writing White Wove

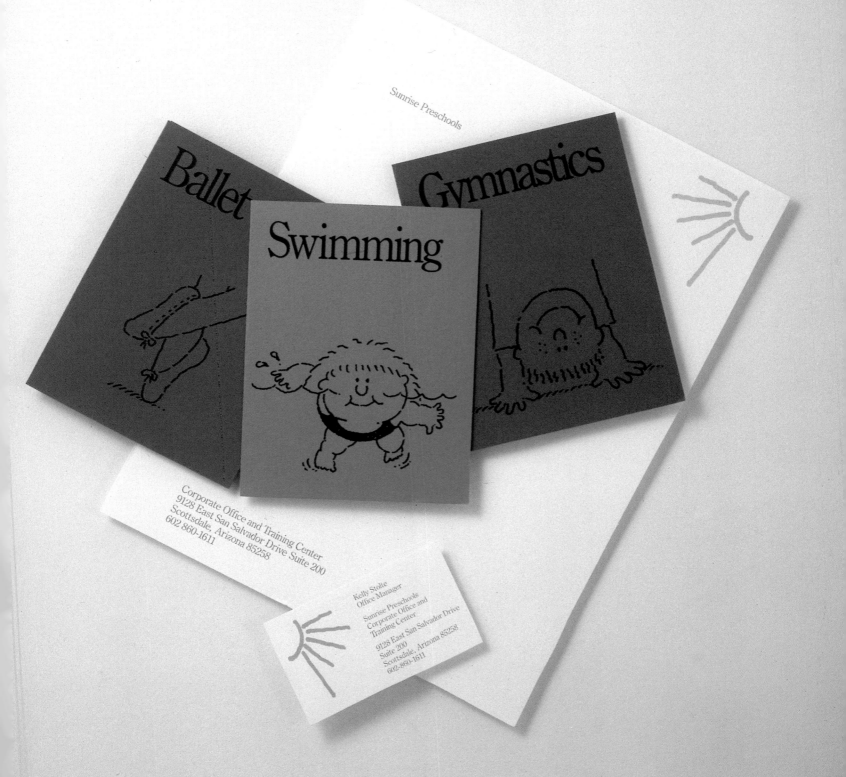

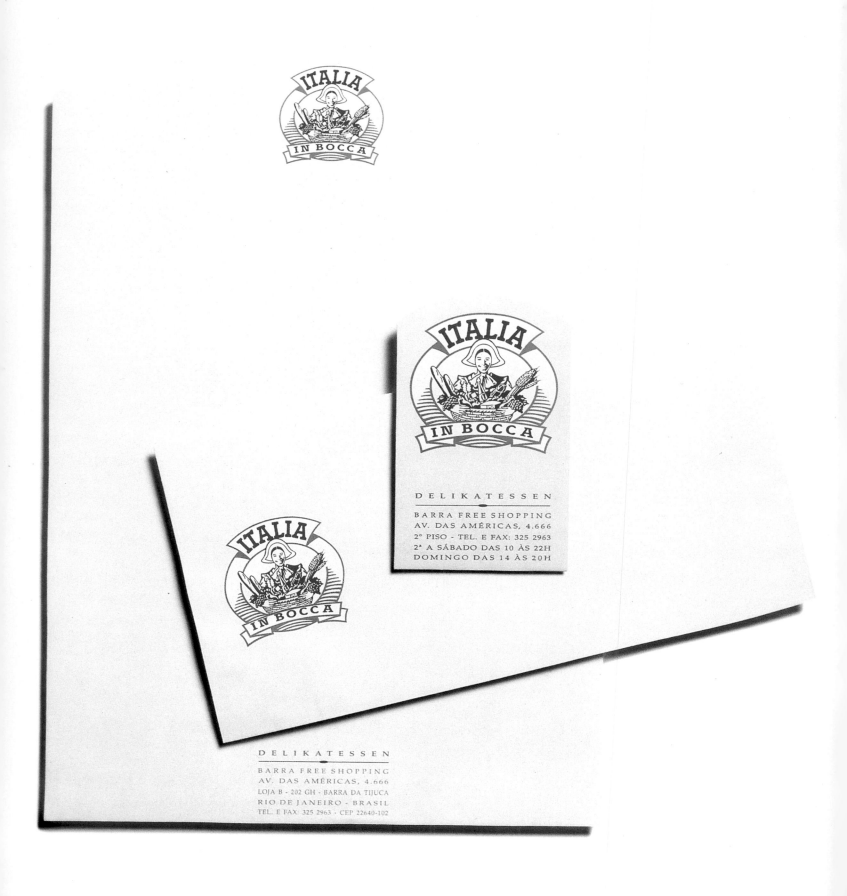

DESIGN FIRM Coker Golley Ltd.
ART DIRECTOR Frank Golley, June Coker
DESIGNER Julia Mahood
CLIENT Clark Brothers

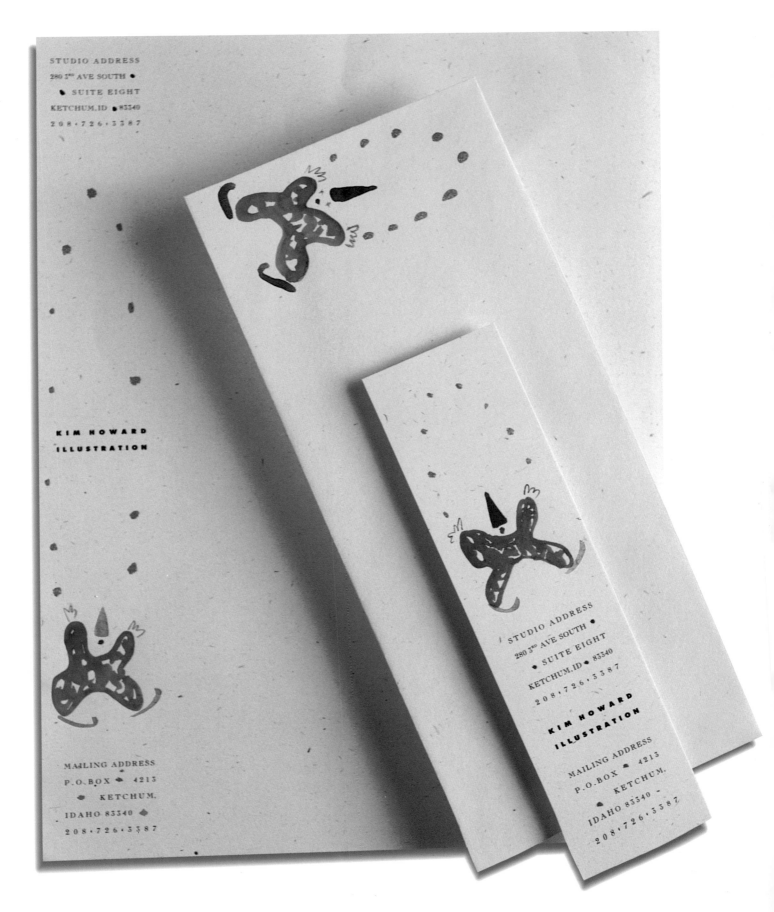

DESIGN FIRM Sackett Design Associates
ART DIRECTOR Mark Sackett
DESIGNERS Mark Sackett, James Sakamoto
ILLUSTRATOR Kim Howard
CLIENT Kim Howard
PAPER/PRINTING Bodoni Speckletone Beach White,
offset litho, black and hand coloring

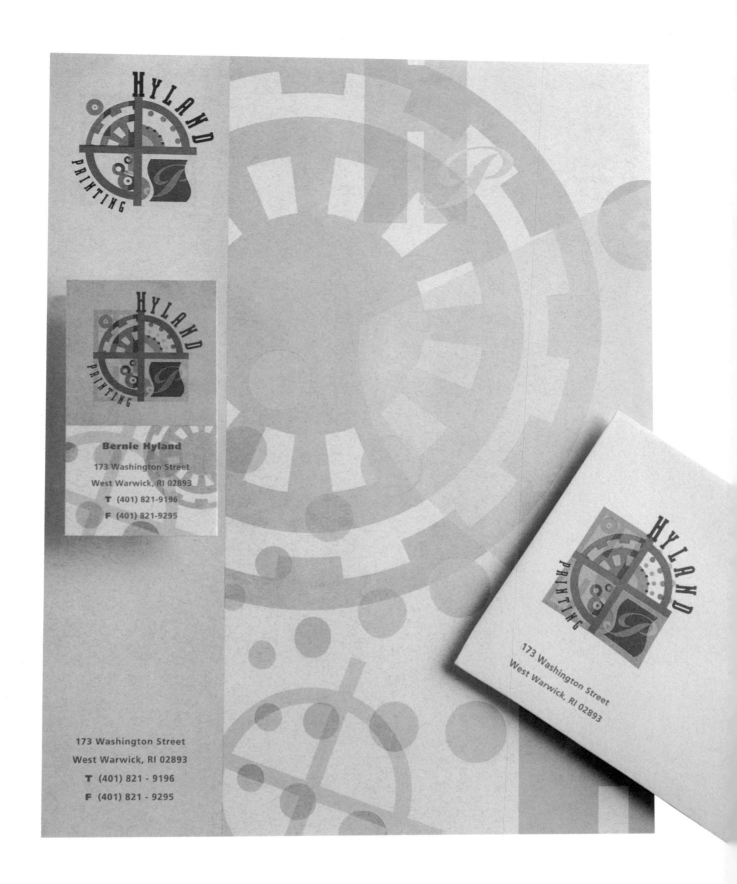

DESIGN FIRM Adkins/Balchunas
ART DIRECTOR Jerry Balchunas
DESIGNER Dan Stebbings
CLIENT Hyland Printing
PAPER/PRINTING Neenah Environment, Hyland Printing

This stationery was printed in four spot colors, three of which were metallic.

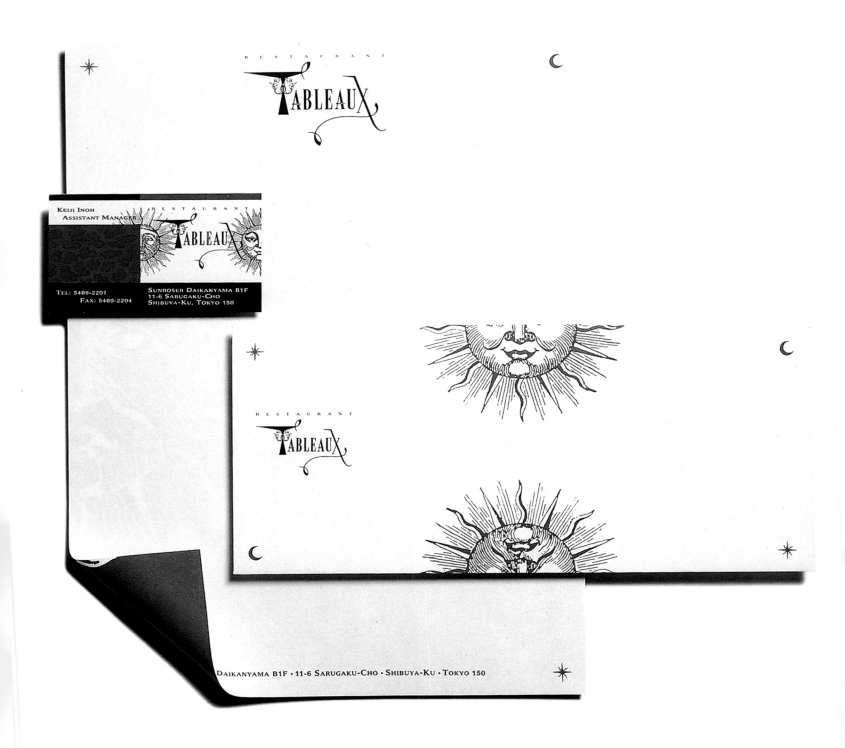

RESTAURANT
TABLEAUX

KEIJI INOH
ASSISTANT MANAGER

TEL: 5489-2201
FAX: 5489-2204

SUNROSER DAIKANYAMA B1F
11-6 SARUGAKU-CHO
SHIBUYA-KU, TOKYO 150

DAIKANYAMA B1F · 11-6 SARUGAKU-CHO · SHIBUYA-KU · TOKYO 150

DESIGN FIRM Vrontikis Design Office
ART DIRECTOR Petrula Vrontikis
DESIGNER Kim Sage
CLIENT Tableaux
PAPER/PRINTING Classic Crest Solar White

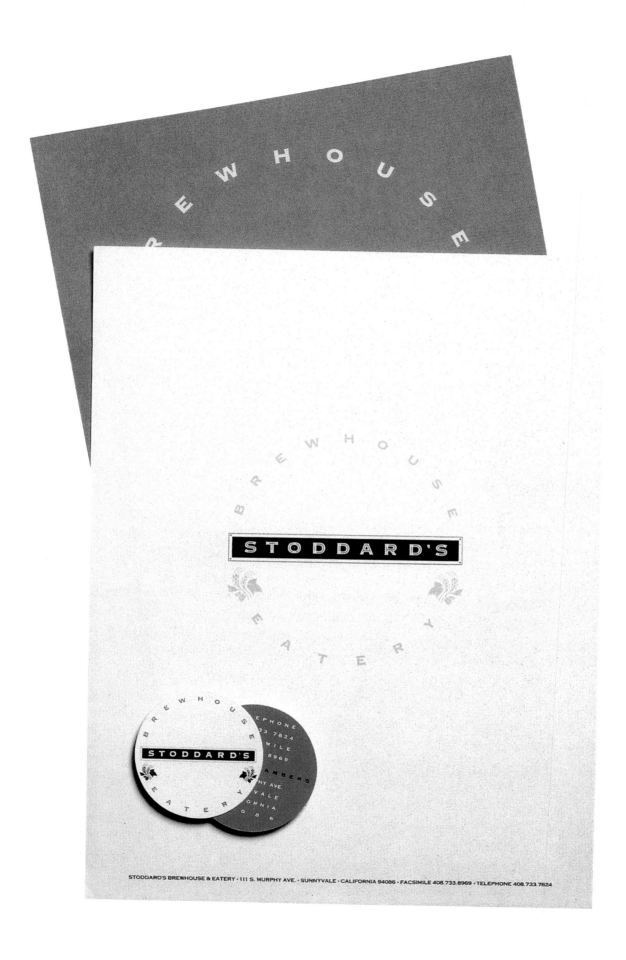

DESIGN FIRM THARP DID IT
ART DIRECTOR Rick Tharp
DESIGNER Sandy Russell, Colleen Sullivan, Rick Tharp
CLIENT Stoddard's Brewhouse & Eatery
PAPER/PRINTING Simpson

Design Firm Swieter Design U.S.
Art Director John Swieter
Designer Mark Ford
Client Street Savage Roller Blade Gear
Tool Adobe Illustrator

This icon was developed for a company that manufactures street hockey equipment.

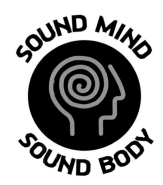

Design Firm Swieter Design U.S.
Art Director John Swieter
Designer Mark Ford
Client ASICS
Tool Adobe Illustrator

This icon was created for the "Sound Mind Sound Body" series.

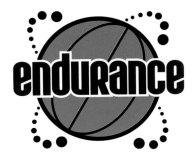

Design Firm Swieter Design U.S.
Art Director John Swieter
Designer Paul Munsterman
Client Converse Basketball
Tool Adobe Illustrator

This product icon was developed for a line of basketballs featuring the highest grade synthetic leather which is durable on all court surfaces.

Design Firm Swieter Design U.S.
Art Director/Designer John Swieter
Client Converse Basketball
Tool Adobe Illustrator

This product icon features a global rendition of the traditional seams on a basketball and is targeted as the first genuine leather ball sold internationally for Converse.

Design Firm Swieter Design U.S.
Art Director John Swieter
Designer Mark Ford
Client Fujitsu
Tool Adobe Illustrator

This logo was created for **Envoy**, Fujitsu's Quarterly Technical Journal.

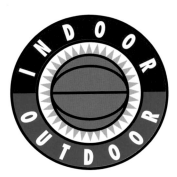

Design Firm Swieter Design U.S.
Art Director John Swieter
Designer Kevin Flatt
Client Converse Basketball
Tool Adobe Illustrator

This product icon created for Converse Inc., symbolizes the use of this product as an indoor and outdoor basketball.

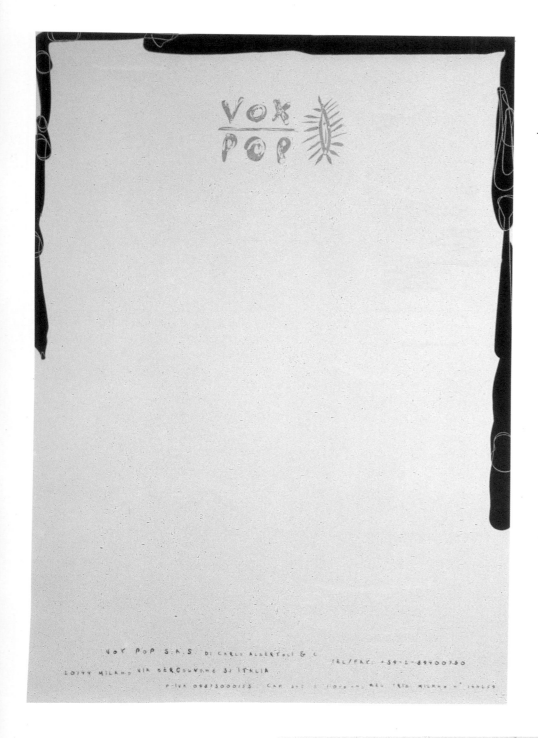

DESIGN Giacomo Spazio, Matteo Bologna for Matteo
Bologna Design NY/ROM Graphixxx Milano
PROJECT Vox Pop corporate identity
CLIENT Vox Pop
TOOLS Fontographer, FreeHand on Macintosh
FONT Vox (custom made)

The font and the logo were designed with a digital
tablet on FreeHand and Fontographer, exploring the
possibility of creating shapes with even/odd fills.

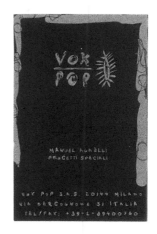

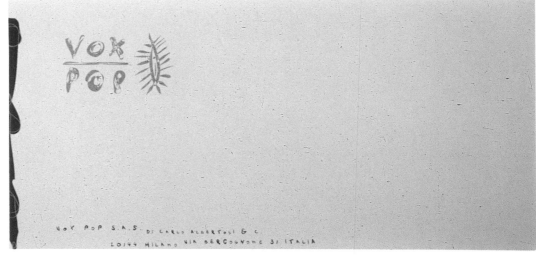

Design Firm Proforma Rotterdam
Art Director Mirjam v.d. Haspel
Designer Michael Snitker
Client Kop van Zuid
Paper/Printing Bankpost